SHADOW
CATCHER

SHADOW
CATCHER

THE LIFE AND WORK OF EDWARD S. CURTIS

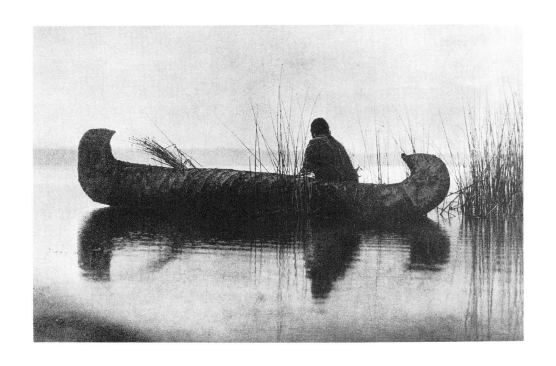

LAURIE LAWLOR

WALKER AND COMPANY
NEW YORK

Special thanks to Polly Jane Curtis Kella and James Graybill for providing invaluable family photos and information. Thanks also to Jane Jordan Browne; Victor Boesen; Margaret Archuleta, curator of fine art, The Heard Museum, Phoenix; Dr. Mary Jane Schneider, professor of Indian studies, University of North Dakota; and Fred Hoxie, director of D'Arcy McNickle Center for the study of the history of the American Indian, Newberry Library, Chicago.

Copyright © 1994 by Laurie Lawlor

Text on pages 5, 22, 57, and 65 from *Edward Sheriff Curtis: Visions of a Vanishing Race* © 1976 by Florence Curtis Graybill and Victor Boesen, Houghton Mifflin; text on pages 38, 41, 51, 62, 66, 67, and 69 from *Edward S. Curtis: Photographer of the North American Indian* © 1977 by Florence Curtis Graybill and Victor Boesen, Dodd, Mead & Company; text on pages 109, 115, and 118 from Edward S. Curtis's *Alaska Journey Journal,* June–October 1927, first published in part in *Edward S. Curtis: Photographer of the North American Indian* © 1977. Reprinted by permission of Multimedia Product Development, Inc., Chicago, Illinois.

First published in the United States of America in 1994 by Walker Publishing Company, Inc.

Published simultaneously in Canada by Douglas & McIntyre Ltd., Toronto, Ontario.

Library of Congress Cataloging-in-Publication Data
Lawlor, Laurie.
Shadow catcher : the life and work of Edward S. Curtis /
Laurie Lawlor.
p. cm.
Includes bibliographical references.
ISBN 0-8027-8288-4. —ISBN 0-8027-8289-2 (reinforced)
1. Curtis, Edward S., 1868–1952—Juvenile literature.
2. Photographers—United States—Biography. 3. Indians of North
America—Juvenile literature. [1. Curtis, Edward S., 1868–1952.
2. Photographers. 3. Indians of North America.] I. Title.
TR140.C82L39 1994
770'.92—dc20
[B] 93-40272
CIP
AC

Book design by Claire Naylon Vaccaro

Printed in the United States of America

2 4 6 8 10 9 7 5 3

For my father,
another artist whose vision endures

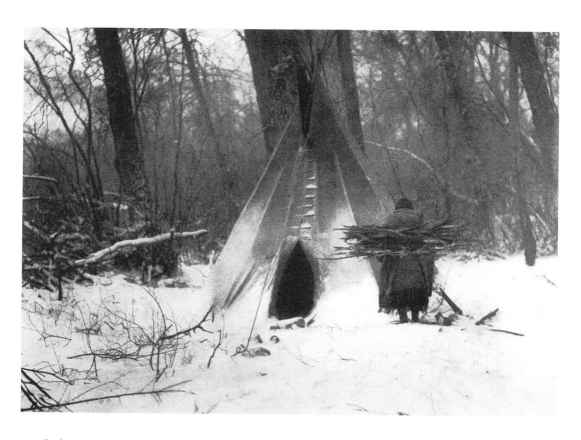

In thick forests along mountain streams the Apsaroke set up winter camp.

ABOUT THE PHOTOGRAPHS

Unless otherwise indicated, all photographs used in this book were taken by Edward S. Curtis for *The North American Indian*. Only about 300 copies were ever printed of Curtis's monumental work, which featured twenty volumes of text and twenty oversized portfolios of photographs. Throughout the United States today, there are probably fewer than 125 sets of *The North American Indian* remaining complete and intact. Most of these are carefully housed in rare book collections of public libraries and other institutions of higher learning.

The North American Indian photographs included in *Shadow Catcher* were reproduced courtesy of Special Collections, Northwestern University Library, Evanston, Illinois. (See the Appendix for further information.) Each image was photographed with a 35mm camera using black-and-white film and high-contrast paper for printing. The images reflect as closely as possible the tone and texture of the originals. Special thanks goes to R. Russell Maylone, curator, and his staff, Ann Tisa, Sigrid P. Perry, and Susan R. Lewis, for their assistance, patience, and support.

AUTHOR'S NOTE

When Edward S. Curtis began what would one day become *The North American Indian*, he assumed that the Native American way of life was about to vanish forever. Fortunately, his dire prediction, like that of many others from his generation, did not come true. Today, Indians throughout North America continue to practice and explore their own rich heritage of traditions and spiritual paths. To find out more about contemporary Native Americans, investigate and enjoy the books listed at the end of *Shadow Catcher*.

One additional note is in order regarding the spelling of Edward S. Curtis's middle name. Records on his mother's side of the family refer to "Sherriff," but the Curtis biography compiled by his daughter, Florence Graybill Curtis, and Victor Boesen give the spelling as "Sheriff." The mystery is compounded further by the fact that Curtis himself never signed his middle name in full. Instead, his signature always appeared as "E. S. Curtis" or "Edward S. Curtis," which is the way the Library of Congress has officially recorded his name.

NORTH AMERICA
Showing the research areas,
cities, and rail routes
important in Edward Curtis's life

——— rail routes
——— waterways

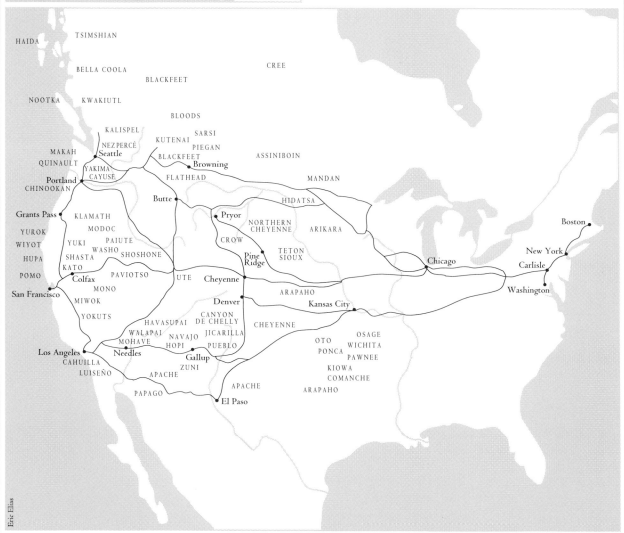

KING ISLAND KOTZEBUE

NUNIVAC

HAIDA TSIMSHIAN

BELLA COOLA

CREE

BLACKFEET

NOOTKA KWAKIUTL

BLOODS

KALISPEL
SARSI
NEZPERCÉ KUTENAI PIEGAN
MAKAH Seattle BLACKFEET ASSINIBOIN
QUINAULT YAKIMA
CAYUSE •Browning
Portland• FLATHEAD MANDAN
CHINOOKAN
Butte• HIDATSA
Grants Pass• KLAMATH •Pryor
MODOC NORTHERN ARIKARA
YUROK CHEYENNE
WIYOT YUKI PAIUTE CROW
WASHO SHOSHONE Pine TETON Boston•
HUPA SHASTA Ridge• SIOUX
KATO PAVIOTSO UTE •Cheyenne Chicago• New York•
POMO Colfax• MONO •Denver ARAPAHO Carlisle•
San Francisco• MIWOK Kansas City• Washington•
YOKUTS CANYON
HAVASUPAI DE CHELLY CHEYENNE
WALAPAI JICARILLA OSAGE
Los Angeles• MOHAVE NAVAJO PUEBLO OTO WICHITA
CAHUILLA Needles• HOPI PONCA PAWNEE
LUISEÑO •Gallup KIOWA
APACHE ZUNI COMANCHE
PAPAGO APACHE ARAPAHO
•El Paso

Eric Elias

SHADOW
CATCHER

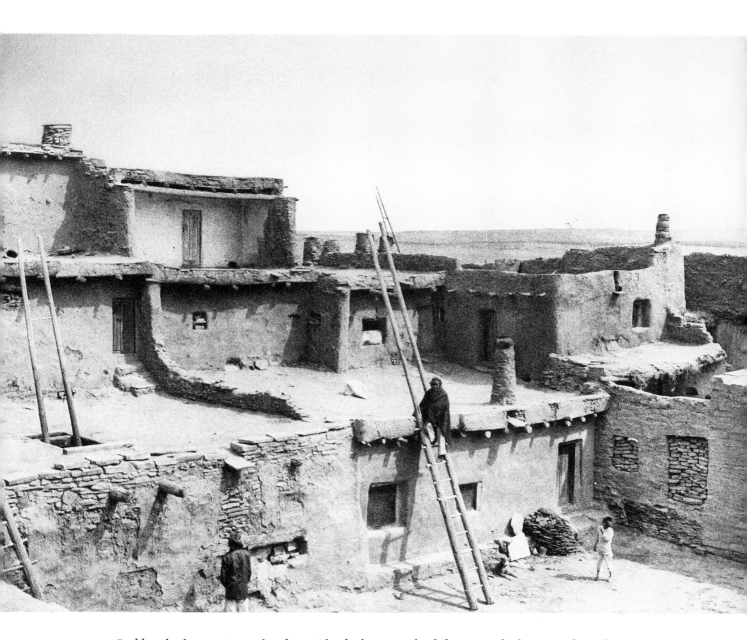

Ladders leading to Zuni chambers. The dark material piled against the house at the right is sheep dung, used for firing pottery.

INTRODUCTION

Often the faces speak what words can never say. Some tell of eternity and others only the latest tattlings. . . . Some of them are worth a long look now and deep contemplation later. Faces betokening a serene blue sky or faces dark with storm winds and lashing night rain . . . faces beyond forgetting.

—from *The Family of Man* introduction by Carl Sandburg

In 1868, the same year that Edward S. Curtis was born, the Oglala Sioux war chief Red Cloud celebrated his first and last victory against the United States government.

Three years of warfare between 25,000 U.S. troops and 4,000 Sioux, Cheyenne, and Arapaho warriors under Red Cloud's leadership had finally convinced the War Department to close the "Bloody Bozeman," a road that ran through prime Indian hunting grounds and ceremonial lands to the gold fields of the Montana Territory. With the last soldiers evacuated, Red Cloud's warriors burned to the ground three Bozeman Trail forts. Triumphantly, Red Cloud went to Fort Laramie to sign what he thought would be a lasting peace treaty. The treaty gave the Sioux all the land west of the Missouri River in the Dakota Territory and promised protection for the sacred Black Hills, which were central to the Sioux religion and culture.

In 1905, when Edward Curtis was a grown man, he met Red Cloud at the Pine Ridge Reservation in South Dakota and asked to take his picture. Blind and almost deaf, the gray-haired eighty-three-year-old chief sat before Curtis's camera with his eyes partially closed, "dreaming of the past."

Nearly forty years had passed since the signing at Fort Laramie. In that

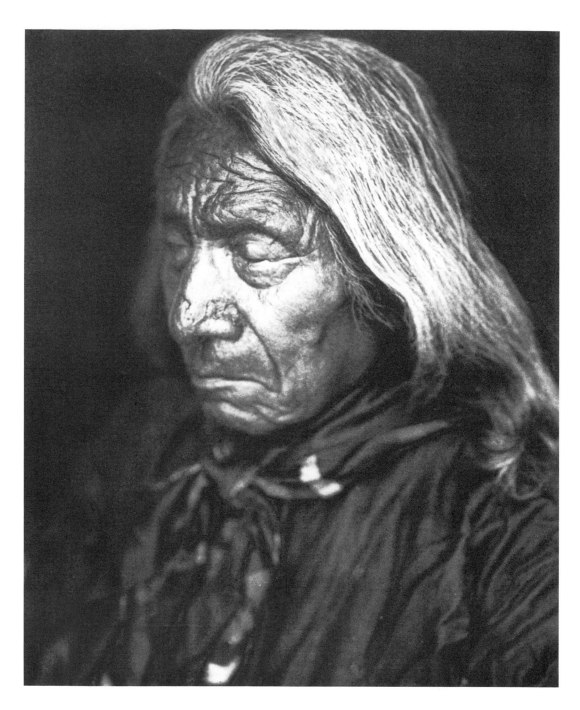

Chief Red Cloud—Oglala Sioux.

time Red Cloud had seen the government break every single treaty promise. The Black Hills, the buffalo, the Great Sioux Reservation—all were gone now. With the discovery of gold in 1874, the Black Hills became white men's territory. A steady stream of trigger-happy miners, professional hunters, and settlers left thousands of buffalo carcasses to rot on the prairie. Cut in half by the railroad in 1889, the Great Sioux Reservation was quickly sold off in pieces to homesteaders by the federal government. The Sioux, who clung to their homeland, were now forced to live on five miserable reservations, "very small islands," as Red Cloud contemptuously called them. "Our nation is melting away like the snow on the sides of the hills where the sun is warm," he said, "while your people are like blades of grass in the spring when summer is coming."

Unlike the government, Red Cloud never broke his promise. After signing the treaty at Fort Laramie, the most powerful leader in the history of the Sioux refused to take up arms against white settlers or soldiers. He had given his word. Stripped of his title by the local Indian agent and eventually ignored by younger Sioux, who advocated violence, Red Cloud maintained his honor up until his death in 1909.

Red Cloud's courage and tenacity were remarkable in the face of betrayal, poverty, and abandonment. Curtis's portrait was not that of a broken warrior. It was that of a man who, in spite of everything, never gave up.

In many ways, the portrait of Red Cloud was also Curtis's own self-portrait. Like Red Cloud, Curtis never gave up.

Curtis envisioned creating something no one had ever tried before. He planned to create "a broad and luminous picture" by chronicling in photographs, words, and sound recordings the changing way of life of more than eighty tribes west of the Mississippi. Many called his project impossible.

Beginning in 1898, Curtis worked for thirty years to complete the twenty volumes of text and photographs, plus another twenty portfolios of photogravure plates, for *The North American Indian*. During this time, he maintained a schedule that would have killed most other people. By foot, horse and wagon, mule, boat, train, and auto, he traveled through every kind of terrain and climate to take more than 40,000 pictures. Not only did he battle Arctic gales on the coast of Alaska; he managed to survive Mojave Desert temperatures

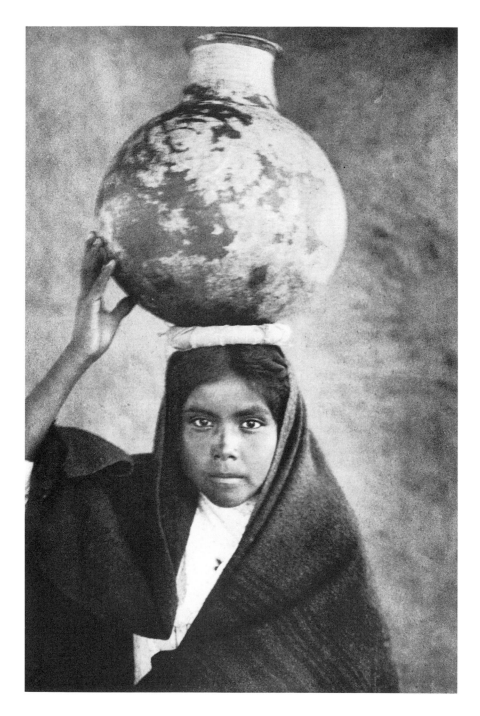

Forty miles south of the Pima reservation in Arizona a young Quahatika girl carries home precious water for her family.

that registered 122 degrees Fahrenheit in the shade. He faced rattlesnakes, rock slides, blizzards, hailstorms, endless rain, and occasionally unfriendly warriors—and he never quit.

With the information he and his crew collected, Curtis wrote four books, supervised sixteen others, collected more than 350 myths and legends, made a feature-length film, and compiled more than 10,000 recordings of music and speech in seventy-five different languages. In order to create this amazing body of work, he had to raise money, lecture throughout the country, and keep just one step ahead of creditors. He gave up family life, assumed punishing debt, and ruined his health.

Curtis envisioned *The North American Indian* as something everyone—not just scholars—could read and appreciate. Using "the best of modern methods," oversized photographs were printed to be as large and beautiful as possible. He saw these as "transcriptions for future generations that they might behold the Indian as nearly lifelike as possible."

Many Native Americans Curtis photographed called him Shadow Catcher. But the images he captured were far more powerful than mere shadows.

The men, women, and children in *The North American Indian* seem as alive to us today as they did when Curtis took their pictures in the early part of the twentieth century. We feel as if we can enter their lives. Studying print after print is an almost hypnotic visual experience. The people seem to wear light. Their eyes are haunting. They stare past us; they penetrate our hearts, our minds.

Curtis respected the Indians he encountered and was willing to learn about their culture, religion, and way of life. "I said 'we,' not 'you,'" Curtis once explained. "I never worked *at* them, I worked with them."

In return, the Indians respected and trusted him. An elderly Sioux, who had shared many hours with him in a circle of fellow tribesmen, said: "He is just like us. He knows about the Great Mystery."

Some modern researchers have criticized Curtis for the way in which he often posed subjects, staged events, or manipulated the photographic printing process. Some have called his work unscientific. From our modern viewpoint, it's easy to find fault with Curtis and his methods. Anthropology—the study of the races, physical and mental characteristics, distribution, customs, and so-

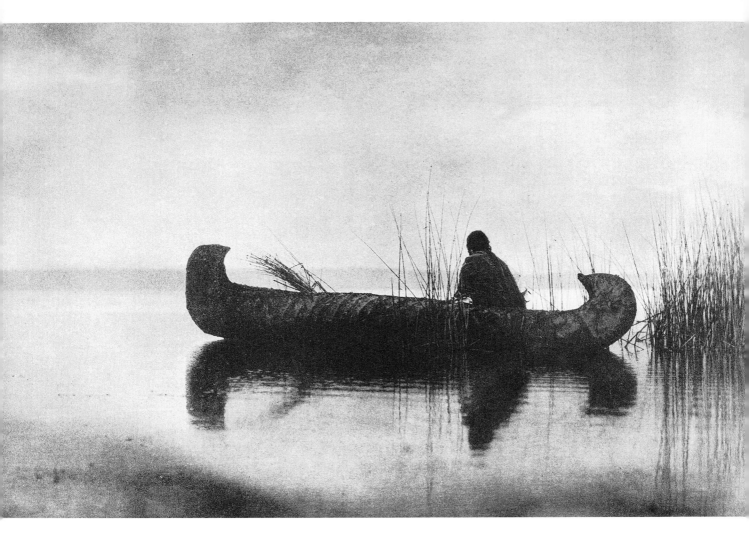

A Kutenai duck hunter of the Pacific Northwest crouches in his canoe in an early-morning fog.

cial relationships of humankind—has changed dramatically since the turn of the century. Today our ways of thinking about investigating, analyzing, and comparing people are very different from those used by anthropologists in the past.

But when judged by the standards of his time, Curtis was far ahead of his contemporaries in sensitivity, tolerance, and openness to Native American cultures and ways of thinking. He sought to observe and understand by going directly into the field. He worked tirelessly to gather information that many

academics during this period had neither the skill, interest, nor courage to collect. Curtis's commitment helped ensure that knowledge of many early tribal ways of life was not lost forever.

Above all, Curtis was an artist. "The results which Curtis gets with his camera stir one as one is stirred by a great painting," wrote one of his contemporaries, naturalist and Indian authority George Bird Grinnell. "When we are thus moved by a picture, and share the thought and feeling that the artist had when he made the picture, we may recognize it as a work of art."

What Curtis left behind is an extraordinary and compelling record. He captured not only individually powerful portraits of famous leaders like Red Cloud, he also photographed countless ordinary men, women, and children— "faces beyond forgetting."

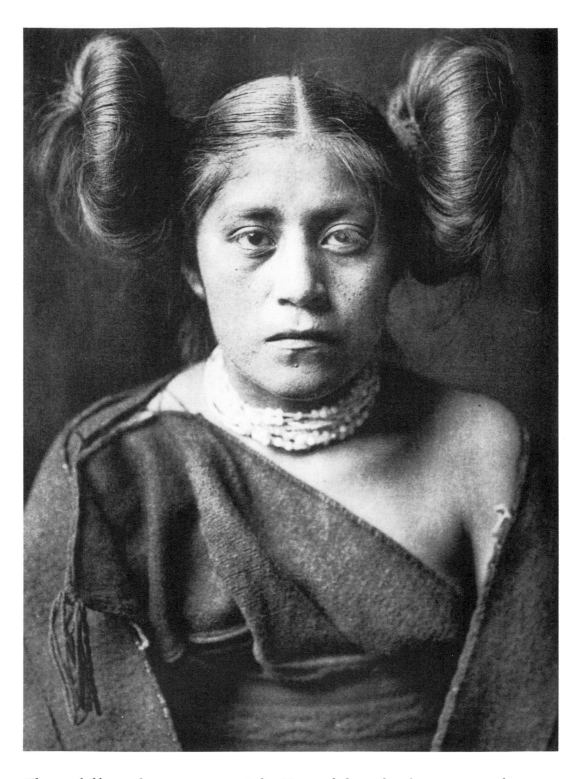

The squash-blossom hair arrangement of this Tewa girl shows that she is not married.

CHAPTER ONE

There were few early clues that Edward S. Curtis would one day grow up to become a famous photographer, a man of enormous energy who was passionately committed to gathering information about Native Americans.

None of his relatives were recorded as being particularly artistic, with the exception of his English-born maternal grandmother, Elizabeth Loxley Sherriff, who made sofa-pillow covers "from old ties and such." As for Indians, by the time Edward S. Curtis was born—February 16, 1868—it had been more than thirty years since the Winnebago people lived along Whitewater Creek near the Curtis home in Cold Springs Township, Jefferson County, Wisconsin.

Edward seldom talked about his hardscrabble childhood in rural Wisconsin and Minnesota. His father, Asahel "Johnson" Curtis, had neither luck nor money most of his life. Edward never knew his father to be anything but ill or even bedridden. He never knew a time when his family wasn't beholden to the generosity of grandparents, aunts, and uncles for their very survival.

Poverty helped forge an incredible drive in Edward. At an early age he became determined to escape from his father's world, from a life of grinding physical labor and failure. He was going to be somebody. He was going to make something of himself.

Of course, what young Edward did not realize was that his father had not always been frail and sickly. There was a time when Johnson Curtis was twenty-two years old and full of energy and hope.

In 1862 Johnson had been so excited about becoming a soldier in the Civil War that he hurried off to Whitewater to sign up with the 28th Wisconsin Volunteer Infantry of the Union army. Johnson was a five-foot-eight-inch, brown-haired, blue-eyed farm boy who knew nothing of the world beyond his father's fields.

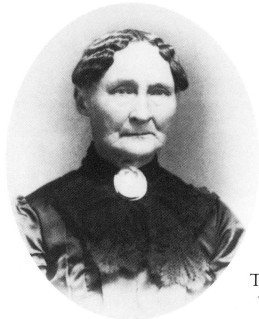

When he marched away, he carried with him a small carved box containing a tintype of his new bride and his baby son. Married just one year, eighteen-year-old Ellen Sherriff Curtis had posed proudly with their firstborn, Raphael (whom everyone called Ray). The baby was barely seven months old.

When Johnson returned to his wife and son in 1865, he had lost his youth and his health. Often ill-clad and ill-fed, he and the rest of the 28th Volunteer Infantry had been packed for days in dirty, crowded transport ships on the White and Arkansas rivers in Arkansas and Texas. Of the 28th's 1,196 total recruits, 222 died of disease—dysentery, "bilious fever," and pneumonia. Only eight died from enemy gunfire.

Johnson made it back alive, although sick and tired. Among other things he brought home in his knapsack was a lens from a stereoscopic camera—something he had probably picked up from a fellow soldier. This lens was part of a camera that had been used to create stereoscopic pictures. A popular form of entertainment in parlors across America during the 1860s and 1870s, stereoscopes provided viewers with three-dimensional views of everything from bathers on the seashore to mountain goats in the Rockies.

Neither Johnson nor any of his relatives could have guessed how this simple stereoscopic lens would one day change the Curtis family fortune.

Three years after Johnson Curtis returned from the war, Edward (or Eddy, as he was called by his family) was born. Two years after Eddy's birth, a baby girl named Eva was born. As the family grew, Johnson struggled to keep up with farm work. But he often had to spend weeks in bed with a wide range of ailments.

Without modern machinery, work on the rolling Jefferson County farmland depended on horsepower and a farmer's own strong back, legs, and arms. Ellen did what she could to help with plowing and planting where the acreage had been cleared of heavy underbrush and thick stands of maple. At the same time, she was responsible for keeping her eye on the three small children and managing the house. "My husband," she later wrote, "has not been able to do but little manual labor since he came home in 1865 and what he has done has been with great difficulty." She described him as "very nervous; very costive [constipated] nearly all the time."

Doctors' visits—when the Curtis family could afford them—never provided lasting cures. It was little wonder, perhaps, that Johnson was seldom in a good mood.

When Eddy turned five years old, the family was uprooted and sent north. Grandfather Asahel Curtis, who ran a prosperous grocery store and served as his town's postmaster, was so well off that he could afford a seventeen-year-old servant girl to help his wife. He had purchased a farm three hundred miles away in Le Sueur County, Minnesota, as an investment. Why not send Johnson, Ellen, and their children to live there?

No record tells what Ellen thought of the move. She was soon pregnant with her fourth child and third son, Asahel, who was born in 1874. A few years later, she gave birth to a little girl, who died as an infant. Throughout these trying times, she was far away from the people who had always been her main support: her parents, three brothers, and five sisters back in Wisconsin.

For seven years, the Curtis family tried to scratch out a living in the Minnesota backwoods. Winter came

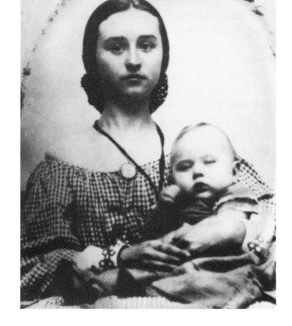

Ellen Sherriff Curtis and firstborn, Ray, in 1862. (Courtesy of Polly J. Kella)

early and stayed late. The farm was located on sandy soil among glittering lakes and fish-filled streams. Not surprisingly, Eddy became an excellent swimmer. He learned how to maneuver homemade boats and rafts in many kinds of currents. The outdoors became a place of fascination for him.

This part of southern Minnesota was wilder and far less populated than Wisconsin had been. Small groups of Santee Sioux lived among the scrub oak along the nearby Minnesota River bluffs. Often despised by white farmers, this handful of Indians had remained in the area after the 1862 Sioux Uprising, which began as a result of broken treaty promises, desperation, and starvation. No exact figure is known for certain, but estimates of settler fatalities during the uprising ranged from 400 to 2,000. More than 40,000 whites fled their homes. Reliable totals of Indian fatalities were not kept. Three hundred and six Santee Sioux and their leader were hunted down to be hanged in retaliation. (President Lincoln pardoned all but thirty-eight.) The rest of the tribe was banished to starvation conditions on a Dakota reservation.

An estimated 3 million to 5 million Native Americans lived in North America in 1492, the time of Christopher Columbus's first landfall. By 1865—a little more than three centuries later—forced migration, warfare, rampaging epidemics, and deplorable reservation conditions had reduced the total Indian population in all of the United States to 300,000.

The Santee Sioux refugees whom young Eddy glimpsed along the Minnesota River may have been the first Indians he ever saw. Driven from their land by white settlers and often cheated out of their annuity payments, Indians throughout America faced daily prejudice and an uncertain future. As a child,

Eddy had undoubtedly heard plenty of stories about "bloodthirsty savages." Since 1864, newspapers across America had been filled with news about the Indian Wars—the last-ditch effort by western tribes to resist extermination or exile to reservations. Between 1866 and 1875, more than 200 battles were reported between western tribes and U.S troops stationed in forts from Dakota to the Mexico Territory. There were also countless smaller-scale raids and counterattacks on stagecoach routes, remote homestead settlements, and Native American villages. Atrocities were committed by whites and Indians alike.

What would it take to end the violence? No one seemed to agree. Some Americans on the East Coast blamed corrupt politicians and Indian agents. They advocated Indian Bureau reform. Others recommended stamping out tribal ways, dividing reservations into farms and training Indians to be farmers and Christians.

Many westerners, whose homesteads were caught in the middle of these territorial struggles, favored the brutal approach of Colonel M. Shivington, who told his troops before battle, "Kill and scalp all, big and little; nits make lice." Within a few hours on November 29, 1864, 300 innocent Cheyenne and Arapaho were massacred at Sand Creek, Colorado. Nearly three quarters of the dead were women and children.

But the solution to the "Indian problem" seemed likely to be solved, according to some newspapers, with the wholesale slaughter of buffalo. The buffalo has always been considered sacred by the Plains Indians and was a main source of food, clothing, and shelter. During the 1870s more than 15 million buffalo were killed by white hunters and sportsmen, who often shot at herds from moving trains. Wouldn't starvation, warfare, disease, and alcoholism spell the end

Asahel Curtis. (Courtesy of Polly J. Kella)

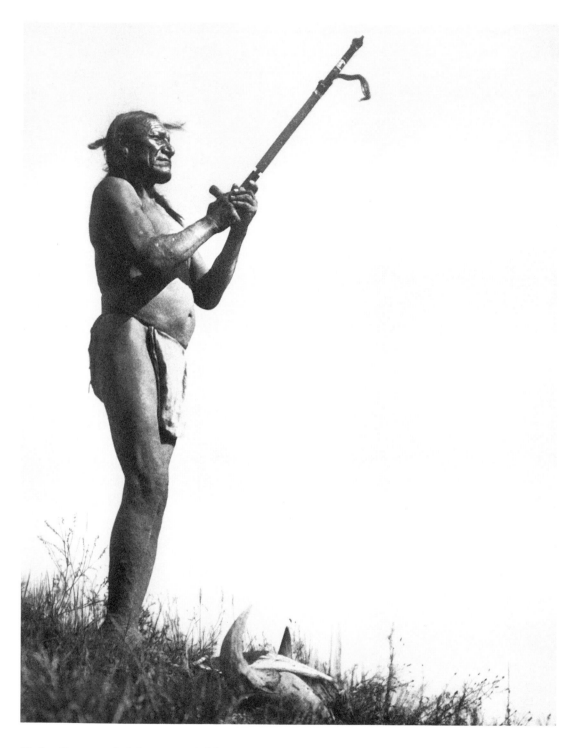

Picket Pin, an Oglala Sioux, holds a pipe aloft to the Mystery. At his feet is the skull of a sacred buffalo.

of insurgent Apaches, Nez Percés, Sioux, Cheyenne, Modocs, and Kickapoo? "These people must die out—there is no help for them," declared journalist Horace Greeley. Like many others, Greeley was convinced that it was America's destiny to civilize or subdue "these red savages" from coast to coast.

No record tells what Eddy or his parents thought about their Indian neighbors in Minnesota. And little wonder. The Curtis family had one main goal: survival. "The climate helped me some at first," Johnson wrote. "Then I failed again. I could not do the work." Farm chores fell increasingly on the shoulders of fourteen-year-old Ray and on Eddy, just turned seven.

In 1880, Grandpa Curtis died and the farm was sold. The family moved to the nearby village of Cordova. Eddy, now twelve, had a chance to attend the local one-room school. The few years Eddy spent in that noisy, crowded classroom would be his only formal schooling.

Meanwhile, Johnson Curtis hoped to make a living running one of Cordova's three grocery stores. Other institutions in the sleepy little village included two blacksmith shops, a wagon shop, two hotels, two sawmills, two churches, and a post office. As luck would have it, his grocery never flourished.

It may have been repeated failures in farming and business or his hopeless health situation that prompted Johnson to pursue a new career. Whatever his reason, forty-year-old Johnson now turned to religion. While leaving Ellen to run the store, he became a part-time preacher for the United Brethren Church.

As part of his job each fall, he had to visit a dozen makeshift preaching places—homes, barns, groves, stores—over a hundred-square-mile area. He traveled wherever he could to "win souls to Christ" and perform marriages, burials, and baptisms for church members in remote settlements. One early church history records that preachers traveled "over long distances where there were no roads and [were] often exposed to all the force of high winds and low temperatures."

To do this strenuous work, Johnson needed help with the paddling and heavy portaging, carrying the canoe and supplies around waterfalls and rocks. By 1881, Ray had left the family home to seek his fortune working odd jobs in Minnesota and later in Iowa. Johnson recruited Eddy, a teenager who was big and strong beyond his years. Eddy could not only paddle and heft enormous supply packs, he could also cook over a fire and perform all camp setup.

While Eddy's experience as a preacher's assistant never made him a churchgoer, it did have a consequence that probably would have surprised his zealous father: Eddy became fascinated by all kinds of different religions. He liked to compare. He liked to question. In later years, he collected a sizable library of books on religion. But the spiritual experience that would always intrigue him most was that of Native Americans, who viewed the world and all of nature as sacred. This undoubtedly made a great deal of sense to Eddy, who all his life was most at home when outdoors.

Unfortunately, the preaching business in rural Minnesota made life harder than ever for the Curtis family. Johnson was gone for long stretches of time. When he and Eddy returned home, they felt lucky to be toting a flour sack full of smoked muskrat legs as payment from grateful church members. Most often the family went for weeks eating boiled potatoes—and not much else.

As he grew older, Eddy found his time increasingly taken up doing chores and finding ways to help support his family. However, when something fascinated him, there was no stopping his "great singleness of purpose" to learn all he could. He had a wide-ranging, hungry curiosity and an insatiable eagerness to try new things. Eddy wasn't afraid of risks; in fact, if something seemed impossible, he liked the idea even better.

Photography had become a popular pastime during the 1880s, and this new hobby sparked Eddy's interest. He decided to build a camera using his father's stereopticon lens. It was a crude bit of work, just two wooden boxes fitted together with an opening for the lens. But Eddy wasn't satisfied with just creating a camera and taking a few pictures for fun. He was going to teach himself everything he could about photography.

Photo buffs could buy simple, inexpensive cameras and dry roll film that did not require the time-consuming, complicated preparation that wet-plate photography once had. There were even manuals available to help the beginning photographer. Eddy managed to get hold of *Wilson's Photographics*, a book first published in 1871, which bore the subtitle *A Series of Lessons Accompanied by Notes on All Processes Which Are Needful in Photography.* He studied the manual cover to cover. In the introduction, Wilson cautioned that photography was "a circus kind of business, and unfit for a gentleman to engage in."

Eddy paid no attention to Wilson's warning. Why should he? Photography seemed far more gentlemanly than chopping down trees or grubbing stumps. With his homemade camera and Wilson's step-by-step advice, a whole new world opened up for Eddy. He could capture forever lifelike images of people and scenes around him.

The problem was the cost. Film and processing supplies were expensive. Any extra money he could earn had to go to his family, not to an impractical hobby like photography. Although Ray had undoubtedly provided his fair share, Eddy described himself during this time as "the main support of our family." There was little cash to spare for "amusements."

Eddy's wages became increasingly critical for the Curtis family when a financial panic in 1883 caused a series of bank failures and a run of farm foreclosures in Minnesota and the rest of the country. With so many farmers in financial trouble, Johnson Curtis's grocery business went from bad to worse. The specter of being forced to go "over the hill to the county poorfarm" haunted Johnson, whose health continued to deteriorate. The Le Sueur County Poorfarm was an overcrowded, underheated building used as a dumping ground for needy people of all ages and conditions, from the insane to the sick and disabled.

Bad luck dogged Johnson. During the summer of 1887, a drought destroyed most of the crops in the area. Without farm trade, his grocery business went bust. Now what?

Ray reappeared in Cordova around this time. During his six years of wandering, he had earned enough cash to buy his father's grocery business and settle down. With Ray's money, Johnson decided to head west to the Washington Territory, where several Minnesota friends and neighbors had already

Edward S. Curtis, about 1890. (Courtesy of Polly J. Kella)

bought land. In the fall of 1887, while twenty-six-year-old Ray stayed behind with his mother, younger brother, and sister, Eddy and his father headed for Sidney, a small settlement in western Washington, just across Puget Sound from Seattle.

The best farmland had already been taken. The few acres nineteen-year-old Eddy and his father purchased were on the beach, not far from sections of cut-over timber. The soil was poor and sandy. But Eddy and his father had high hopes. All around them the air was filled with the smell of spruce. At their feet ocean waves lapped. The two men marveled at peaks of snow-covered mountains that seemed to meet the sky in the distance. Unlike Minnesota's winter and early spring, the weather here felt mild, almost soothing. They did not even mind the constant rain. How could they, after the awful drought they'd just been through?

Eddy went to work chopping trees and building a log cabin with a large stone fireplace. For a while, it seemed as if the new climate had improved his father's health. Johnson helped with "light work" around the new homestead. Sometimes he took the skiff to town, where he visited with other members of the Grand Army of the Republic. He even had a new business scheme. In just a few months he hoped to buy and operate a brickyard.

Eddy and his father sent encouraging letters home. In spite of their glowing accounts, Ray could not be convinced to leave Cordova. He had a sweetheart in town. But in the spring of 1888, Ellen and the other children, Asahel and Eva, eagerly boarded an emigrant railroad car going west.

But Johnson's health had already started to fail. "He was too ambitious . . . and took a severe cold which settled on his badly diseased lungs, and the end

came quickly," the local newspaper reported. The family was reunited only three days before Johnson Curtis died of pneumonia on May 2, 1888.

After her husband's death, Ellen decided to stay in Washington. "Mother wrote to say she liked the country better than Minnesota," Eva said in a letter to Ray. As a Civil War widow, Ellen was eligible for her husband's military pension of sixteen dollars a month. But that would not be enough money on which to live.

Since Ray was in Minnesota, Eddy had become the head of the family. It was up to him to figure out a way to support his mother and younger brother and sister. He took his new duties seriously. "Edward had the full responsibility of the family and he felt the load," Eva later wrote. "There was never any frivolity about him."

Asahel Curtis. (Courtesy of Polly J. Kella)

CHAPTER TWO

With help from thirteen-year-old Asahel, Eddy tried to make money by chopping firewood, digging and selling clams, fishing, and growing vegetables. Even though it was a struggle to eke out any kind of living, he had not lost his fascination with photography. When he turned twenty, he bought a fourteen-by-seventeen-inch large-view camera that used glass plates. (The camera's seller was a miner who was trying to grubstake a claim in California.)

Eddy probably looked with longing across Puget Sound to Seattle, where life was exciting and anything seemed possible. Since a fire in 1889 that had destroyed much of the downtown, Seattle was busy rising out of the ashes, bigger and better than ever. Sawmills hissed day and night. The place buzzed with building, blasting, digging.

In just ten years, from 1880 to 1890, Seattle's population had skyrocketed from 3,553 to 42,837 people. Any day the proud citizens expected the arrival of the transcontinental railroad, which would surely transform their city into a major American seaport.

This booming, bustling, brand-new metropolis seemed just the place for someone as energetic and determined as Eddy. Only years later did he reveal another reason he went to Seattle. "I had a family to support. A spinal injury made it impossible to work in the lumber yards. Knowing a little about photography, I bought an interest in a small photo shop." When and how he injured his back he never fully explained. He seldom talked about personal injuries or complained of ailments, even to family or close friends. Growing up with a father who was always ill may have made him intolerant of his own physical weaknesses.

His decision to buy an interest in a small photo shop required cash—something that was in short supply among the Curtises. Boldly, Edward Curtis took his first gamble: He mortgaged the family farm. With a $150 loan he

bought a part interest in a photography studio from Peter H. Sanstrom, a friend and neighbor from Cordova. This was his big chance. He became partners with another local photographer, Rasmus Rothi. Their little shop, located in one of Seattle's many alleyways, was renamed Rothi and Curtis Photographers.

Curtis was not all business. He had a sweetheart, Clara Phillips. She was dark-haired and pretty. "Bright, well-read, a good conversationalist," one relative remembered her. "She shared Edward's love for this great, scenic land of the Northwest—but not his interest in photography." Clara's family lived on the Kitsap Peninsula, not far from the Curtis cabin near Sidney. She had come to Seattle to work around the same time that Curtis arrived, and may have lived in the same neighborhood where Curtis rented a room in a boardinghouse. In 1892, eighteen-year-old Clara Phillips and twenty-four-year-old Edward Curtis were married.

One year later Curtis made another bold business move: He entered a new partnership with Thomas Guptil. Together they did portrait work and engraved printing places, which were used to reproduce photos and drawings in local publications. Curtis and his wife lived above the photo studio. Here, on November 18, 1893, their first baby, Harold, was born.

With characteristic enthusiasm, Curtis threw himself into his work, learning everything he could about fine portrait and engraving methods. He read about the latest techniques and joined several professional organizations. Photographers at the time were rethinking how to take portraits. Some tried to capture the personality of the individual through strategic, often dramatic lighting. Curtis studied how to best use light to create a certain mood or to capture a certain feeling. In the 1894–95 Seattle business directory, "Curtis and Guptill [sic], Photographers and Photoengravers" were listed as providing "the finest photographic work in the city."

Business boomed. Things were going so well that Curtis invited his mother, Asahel, and Eva, who had been working as a schoolteacher, to come to Seattle and live with them in a large boardinghouse. Asahel took a job in the studio as an engraver and quickly learned photography from his brother.

In 1896 Curtis was undoubtedly delighted when he and Guptil won their first award, a bronze medal from the National Photographers' Convention in

Eva Curtis, sister of Edward and Asahel.
(Courtesy of Polly J. Kella)

Chautauqua, New York, for excellence in posing, tone, and lighting. The studio had begun to experiment with a new type of photograph printed on a plate coated with an emulsion containing gold or silver. "This method . . . is brilliant and beautiful beyond description," said Seattle's *Argus* newspaper, which called Guptil and Curtis "the leading photographers on Puget Sound."

That same year, the Curtises' first daughter, Beth, was born. The family moved to a big house six blocks from the studio, where they would live for the next six years. Here, a second daughter, Florence, would be born in 1898. The place quickly filled with an ever-expanding clan of family and in-laws, including Curtis's mother, sister, and brother and numerous cousins and distant relations of his wife. All worked at the studio.

In 1897, Guptil went his own way and the name of the business changed to "Edward S. Curtis, Photographer and Photoengraver." Seattle's wealthy citizens flocked to the studio to have their pictures taken. Social belles claimed a portrait from Curtis's studio "gave them glamour." Customers found the studio's owner handsome and charming, with his gentlemanly Vandyke beard and his wide-brimmed hat rolled up jauntily on one side. "He was big, six feet two inches, husky, ruggedly built," his daughter later recalled, "yet with this he had a soft voice with a pleasing tone that inspired confidence."

Nothing about Edward S. Curtis, photographer and photoengraver, betrayed the desperate poverty of his youth.

Throughout the 1890s, he was the city's premier society photographer. But his favorite photographic subjects were not the rich and famous. Whenever he could, he escaped the studio and climbed into the mountains with his camera

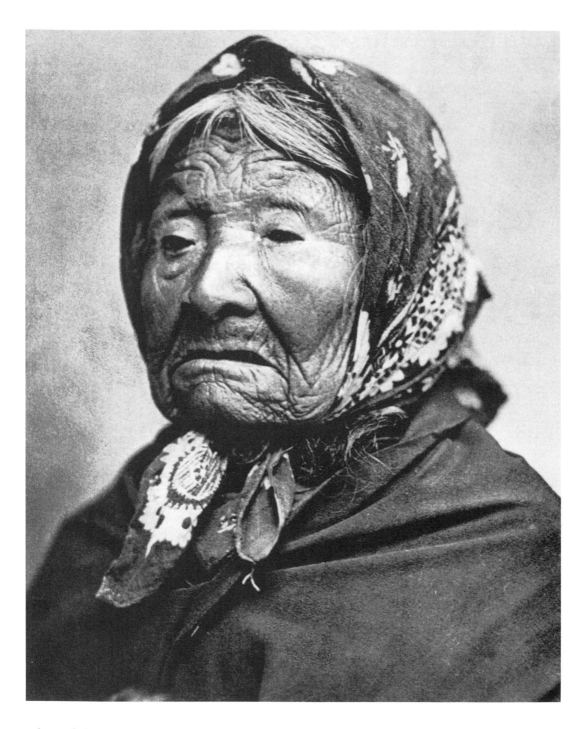

The aged daughter of Chief Seatlh (Seattle) was named Princess Angeline by residents of Seattle.

and supplies on his back. High in the Olympic and Cascade ranges, he took dramatic yet meticulous shots of the splendid scenery. He called Mount Rainier, the 14,410-foot giant that towers over the Northwest Coast, "my beloved mountain of mountains." Not content to just hike along ordinary trails, he taught himself climbing techniques. Soon he was leading overnight expeditions up the steep, dangerous sides of Rainier.

But mountain landscapes weren't the only things that fascinated Curtis. More and more he had become intrigued by the Native Americans who had thrived in the Puget Sound area before white men arrived. He and a friend, Duncan Inverarity, often visited the nearby Tulahip Reservation to take pictures of the Makah, Quinault, and Salish Indians as they fished and hunted seals. The Indians were often forced to sell baskets on Seattle streets or pick hops in the fields south of the city to make enough money to survive. "[One] Sunday afternoon . . . Ed and I were out with cameras, as usual, looking at the Indian Hop Pickers who were just beginning to come in near the Old Yacht Club moorings," Inverarity wrote many years later. "This was the first Indian picture that Curtis ever made and the beginning of his Indian collection."

It was around 1895 or 1896 that Curtis met the aged daughter of Chief Seatlh, the Suquamish Indian from whom Seattle got its name. Princess Angeline, as she was called by whites, was barely making a living gathering firewood and digging clams in the tidewaters near her waterfront shanty. "I paid the princess a dollar for each picture I made," Curtis wrote. "This seemed to please her greatly and with hands and jargon she indicated that she preferred to spend her time having pictures made than in digging clams."

These "Indian views" were offered for sale at the studio, along with the landscape photographs. Tourists bought them as souvenirs.

On July 4, 1897, Seattle reeled with news of an incredible discovery in Alaska: Gold! Nuggets as big as your fist and just lying on the ground waiting to be picked up! Suddenly, the city filled with prospectors from across the nation, all waiting to catch whatever boat was going north to try and make their fortunes.

Curtis caught his own kind of gold fever. He decided that the studio would go into the "Alaska view business on the most gigantic scale ever attempted." His plan was to send twenty-three-year-old Asahel, who was becoming a tal-

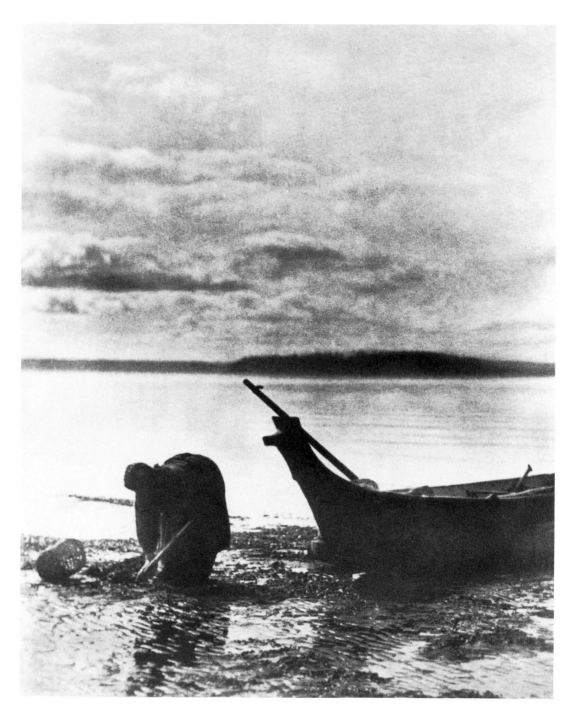

Clams, an important food source for Northwest Coast tribes, are gathered using a wooden digger called a dibble. Many of Curtis's earliest Native American photos were of clam diggers from the nearby Tulalip Reservation in Washington State.

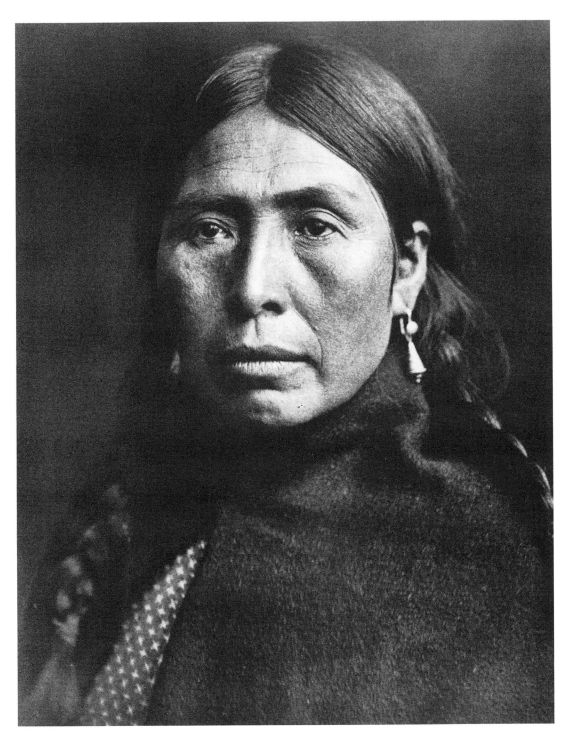

Lummi woman. The Lummi tribe originally lived in Lummi Bay and the San Juan Islands of Washington State, not far from where Edward Curtis's family settled.

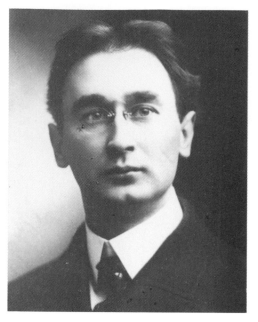

ented photographer in his own right. Asahel was to travel north to the Klondike, where he would take more than 3,000 photographic plates. "These views will cover not only the explored portions of Alaska," a Seattle newspaper announced, "but it is the intention of the party to take views of sections on which the human foot has never been placed."

If Curtis wished that he were the one taking those pictures on such a dangerous, exhilarating adventure high in the Alaskan mountains, he never told anyone. But he must have felt restless as he and the rest of the family waved good-bye to Asahel, who left in December 1897 aboard the *Rosalie*, carrying a year's supply of food and several hundred dollars in camera equipment. Although the Yukon venture was a big gamble, it wasn't the possible loss of money that bothered Curtis. It was the missed opportunity. While his brother was climbing and taking glorious shots, he would be trapped back at the studio.

Little did Curtis realize that a strange and marvelous coincidence would soon send him on his own journey.

In early spring 1898, Curtis and one of his female studio assistants were ascending Mount Rainier to take pictures when they discovered a group of bewildered, cold, and hungry climbers. Were they lost? Yes. Did they have any idea how close they were to the treacherous snow-hidden crevasses of Nisqually Glacier? No.

"I managed to get them to my camp where I thawed them out," Curtis said. He must have been surprised when he learned that his guests weren't ordinary mountaineering enthusiasts. They were prominent scientists, government officials, and naturalists from Washington, D.C. The group included Dr. C. Hart Merriam, a physician and naturalist and chief of the U.S. Biological

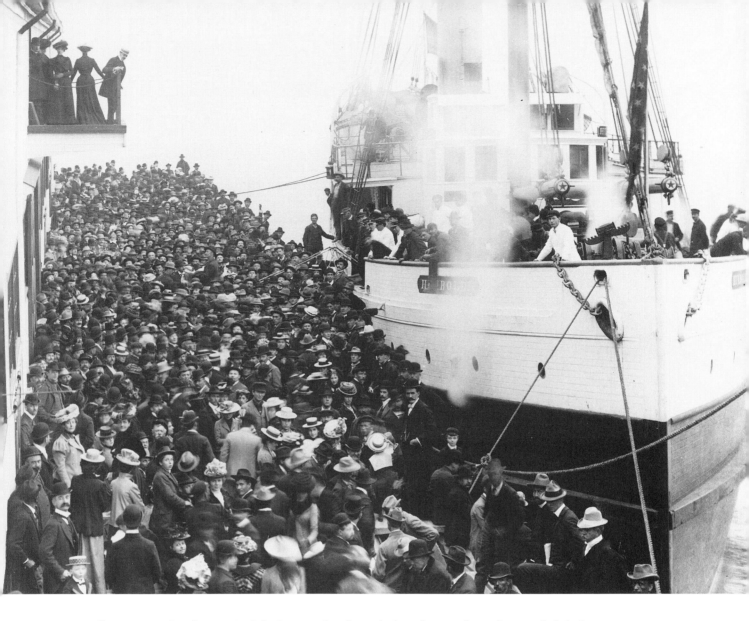

All eyes seemed to be on Asahel Curtis when he took this photograph of the crowded docks of Seattle around the time that gold was discovered in the Yukon. (Reproduced with permission of Special Collections Division, University of Washington Libraries, Neg. WW 7807)

Survey; Gifford Pinchot, head of the U.S. Forest Service; and George Bird Grinnell, editor of *Forest and Stream* magazine, naturalist, and Indian authority.

The next day, Curtis gave the group a tour. "I acted as their guide in giving the mountain the once-over," he recalled. Grinnell and Merriam were obviously taken with his gracious manner and friendly good humor. With their exploration of Mount Rainier completed, they returned with Curtis to Seattle

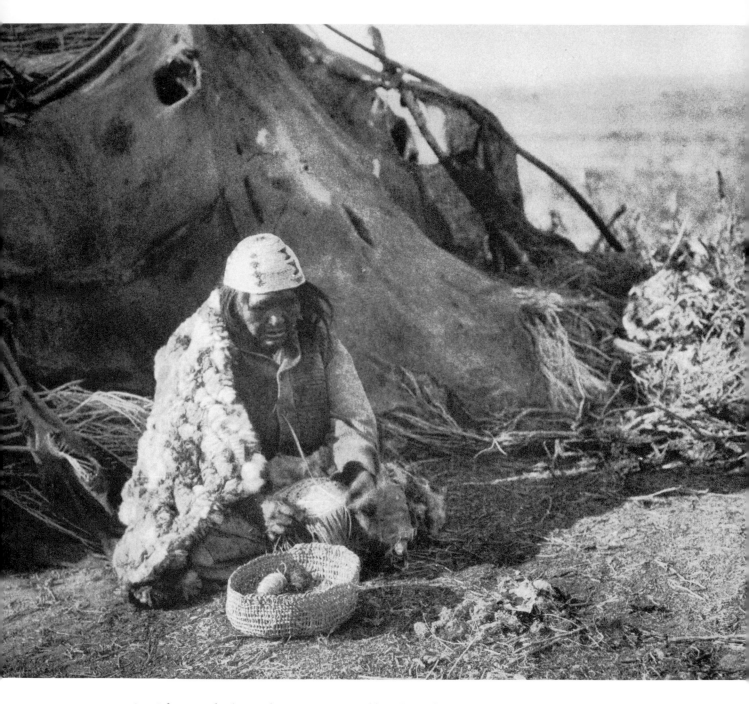

An Achomawi basket maker, wearing a rabbit-skin robe, creates a basket in front of a summer residence, a conical tipi covered with tule mats.

to visit his studio and see some of his landscape and Indian photos. Grinnell and Merriam did not forget Curtis when they left. They kept up their friendship through letters.

Curtis's big opportunity came the following year. Merriam sent him an irresistible invitation. Would he like to come along on a scientific expedition to Alaska as official photographer? Curtis wasted no time in his reply. Absolutely! And just for good measure, he would ask along his friend Inverarity to be his photographic assistant.

Edward Curtis, self-portrait, 1899. (Reproduced with permission of Special Collections Division, University of Washington Libraries, WW 2807)

CHAPTER THREE

The two-month Alaska expedition set out to explore the economic resources of America's "last frontier." Railroad tycoon Edward Harriman, who planned and funded the trip, had come up with the idea after being ordered by his doctor to take a vacation. But Harriman was far too ambitious to waste time relaxing.

Why not cruise up the coast of Alaska on a grand scientific adventure—something splashy that the newspapers would be sure to cover? Such a generous contribution to science would certainly improve Harriman's standing with the rich bluebloods on the East Coast. And if he also secretly assessed the possibility of building a trans-Alaska railroad line with a bridge crossing the Bering Strait to Siberia—well, what harm was there in that?

On May 30, 1899, a crowd stood on the Seattle dock waving good-bye as the *George W. Elder* set sail. Aboard were twenty-three of the nation's top scientific authorities, artists, and writers, including naturalists John Muir and John Burroughs. Also on board were Mr. and Mrs. Harriman and their two young sons plus eighty-nine ship's officers, deckhands, packers, hunters, medical personnel, stenographers, and taxidermists to stuff and mount the animals collected on the trip. The shipboard library was stocked with 500 volumes. The kitchen staff was prepared to offer the travelers a new delicacy every evening. Clearly, this was no low-budget excursion.

Rubbing elbows "with men of letters and millionaires" in such opulent surroundings must have seemed like a dream come true for someone like Curtis. This exposure to new ideas, field techniques, and ways of looking at the world would have a profound and lasting effect.

As the ship sailed past the intricate glacial sculpture along the shore, the scientists and men of letters "gazed and sketched and took photos of the glorious show of mountains," wrote John Muir in his journal. When the ship dropped anchor in a promising bay, the scientists were rowed ashore to explore

and collect specimens of minerals, plants, and animals. Even mealtime was not wasted. Every night a different speaker presented a new subject.

Curtis, who was principally a landscape photographer on the trip, worked tirelessly to produce nearly 5,000 images of glaciers, mountain ranges, and other geological formations. "The summer days in Alaska are long on both ends and Mr. Harriman urged that I make use of all the daylight," he said.

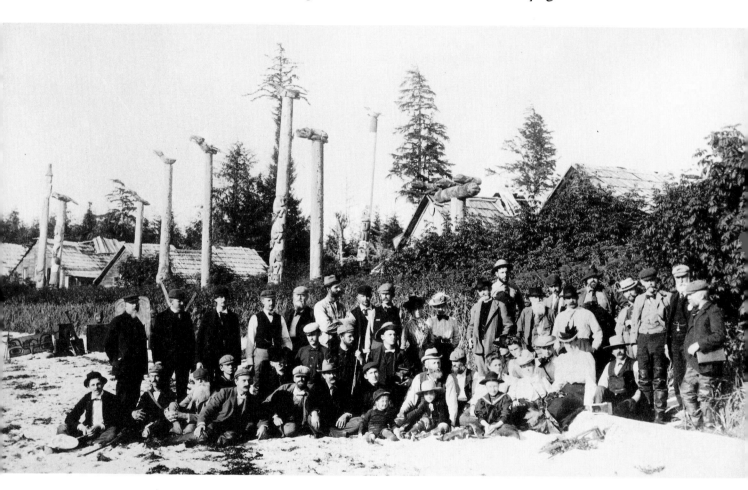

A group shot from the Harriman Expedition. George Bird Grinnell stands third from the right. Dr. C. Hart Merriam is seated on the far right, in the white Stetson hat. Next to him, sitting on the log, is Mrs. E. Harriman, flanked on her right by her three daughters and their guests. Edward H. Harriman stands directly behind his wife, with John Burroughs on his right. John Muir was also along, but is not shown here; nor is the photographer, Edward S. Curtis. (Edward S. Curtis, courtesy of the Smithsonian Institution)

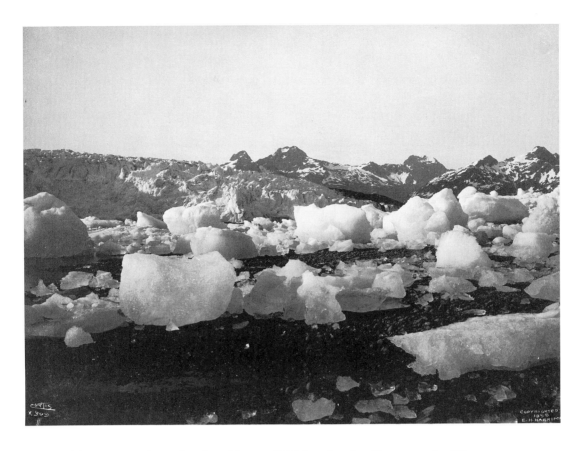

Stranded bergs from the Columbia Glacier, 1898, taken by Curtis on the Harriman Expedition. (Reproduced with permission of Special Collections Division, University of Washington Libraries, Harriman 98)

For someone as entranced with light as Curtis, photography above the Arctic Circle must have been breathtaking. Nowhere else in the world is there such "a fullness and subtle quality of light. . . ." one Arctic expert wrote. "At certain hours the land has the resolution of a polished diamond."

Curtis was not afraid to take personal risks to get a dramatic shot. Once, he and Inverarity went out in a light canvas canoe to take close-ups of Muir Glacier. Suddenly, the wrenching sound of splitting and cracking ice filled the air as a new iceberg broke from the glacier and toppled into the water. Huge waves rose. Only luck and expert paddling saved Curtis and Inverarity from capsizing or being crushed. Somehow they managed to keep the water-filled boat afloat long enough to return to the ship, where onlookers cheered on deck.

Curtis spent most of the expedition as an eager student. From Merriam he observed how to take photographs of Native cultures. From Harriman he learned how to use wax cylinders to create recordings of Indian speech. Most important, he spent time with Grinnell, who related his twenty years' experience living among the Blackfeet Indians. This was Curtis's first exposure to professional ethnology, the study of other cultures.

There were also some dark lessons for Curtis. He saw the wasteful way in

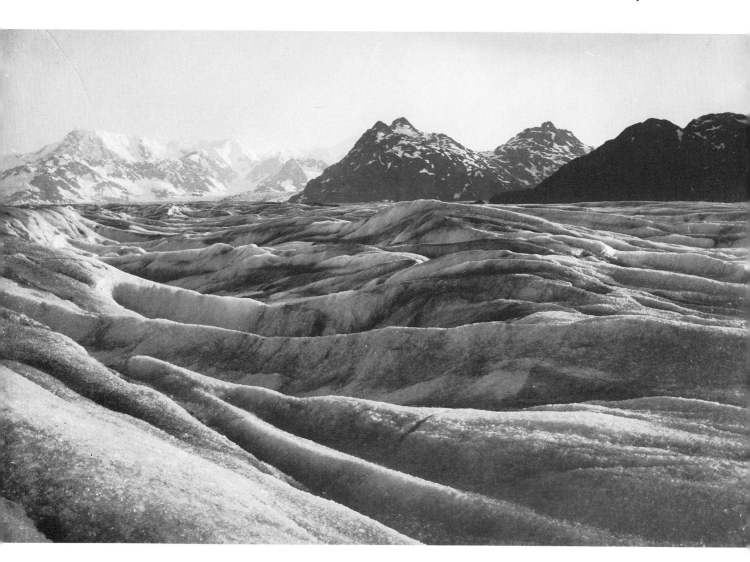

The way to Nunatak—ridged ice (Edward S. Curtis, courtesy of the Smithsonian Institution)

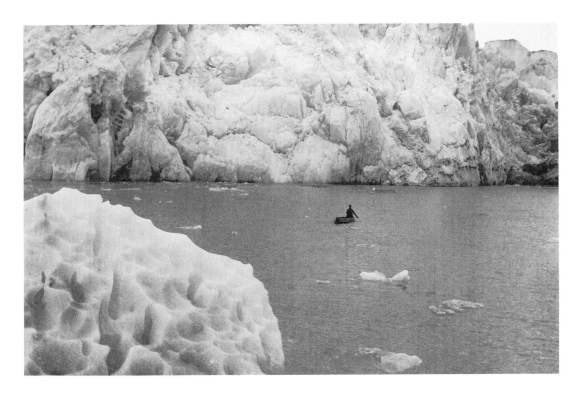

Curtis photographed Glacier Bay during the Harriman Expedition. The canoeist is thought to be Duncan Inverarity. Not far from this spot, Curtis and Inverarity were nearly killed when ice fell from the glacier while they were taking photographs from a similar canoe. (Reproduced with permission of Special Collections Division, University of Washington Libraries, Harriman 30)

which Alaska was being stripped of its resources. "In places," Burroughs wrote, "the country looks as if all the railroad forces in the world might have been turned loose to delve and rend and pile in some mad, insane folly and debauch."

So many animals had been hunted or scared off that the only specimens the visiting scientists caught in their traps were mice and shrews. At one point, they became excited when they thought they saw a polar bear in the distance. It turned out to be a group of white swans.

Toward the end of the journey, the expedition came upon a mysteriously deserted Inuit village. The scientists hurried ashore to strip the place of everything they could—from children's clothing hanging from the rafters, to burial

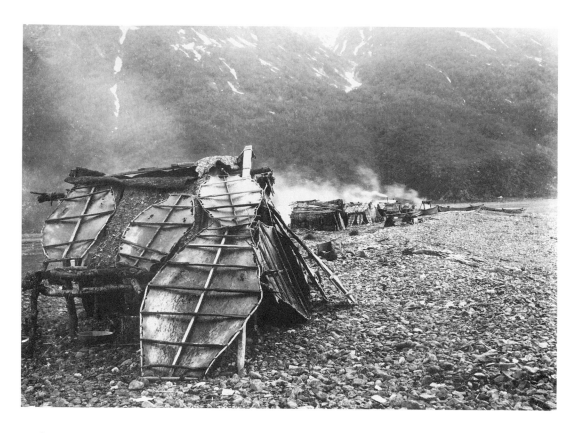

*Sealer's camp—Yakutat Bay (Edward S. Curtis, courtesy of the Smithsonian
Institution)*

blankets, to totem poles. Muir grumbled in his journal about the "robbery,"
although most of the others viewed the abandoned village as a great find.

How did Curtis feel as he watched the Indians' personal belongings being
crated and loaded onto the ship? Since he did not keep a journal, we cannot
know for sure. But years later, not far from the same spot, he would have
severe words for three scientists he met plundering a Native burial ground and
carting off "about a ton of human bones in sacks."

Many of the "artifacts" collected on the Harriman expedition would even-
tually go on display in museums across the country. There was a great growing
hunger at the time among Americans for images and information about Indi-
ans. With the violence west of the Missouri ended and Indians confined to
reservations, the "vanishing" tribes seemed permanently vanquished. The pub-

lic saw Indians now as "noble savages." They were glorified in books, magazines, and circus shows. The Wild West, according to popular culture, had become the true home of tough, self-reliant individualists.

When the *George W. Elder* pulled into the port of Seattle on July 30, "the end of a glorious trip," the hold was crammed with so many specimens that it would take nearly fifteen years and thirteen volumes to publish all the discoveries. During the summer of 1900, Curtis worked feverishly to print his photographs for the expedition's *Souvenir Album*. His editor, Merriam, was a perfectionist, who often returned photographs he felt had been cropped poorly. The experience undoubtedly heightened Curtis's own standards.

Sealer's shack—Glacier Bay (Edward S. Curtis, courtesy of the Smithsonian Institution)

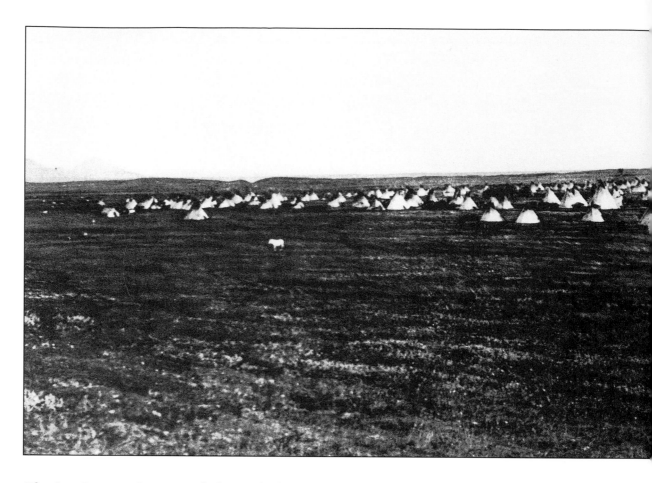

This Sun Dance gathering of Blackfeet, Bloods, and Algonquin on the Piegan Reservation in Montana in 1898 was an inspiring experience for Curtis and a catalyst for his later work.

Back in Seattle after his adventures on the expedition, life must have seemed somewhat dull and uneventful. True, the Curtis family was well and even enjoyed occasional vacations together at the log cabin on the waterfront in Sidney. Harold had just turned six, Beth was three, and Florence was almost two.

The studio had expanded to include a gallery area and a new innovation, a telephone. Curtis even found time to guide 108 Kiwanis to the top of Mount Rainier and get himself elected vice president of the Pacific Northwest Photography Association.

Even so, he was feeling restless. He needed some new challenge.

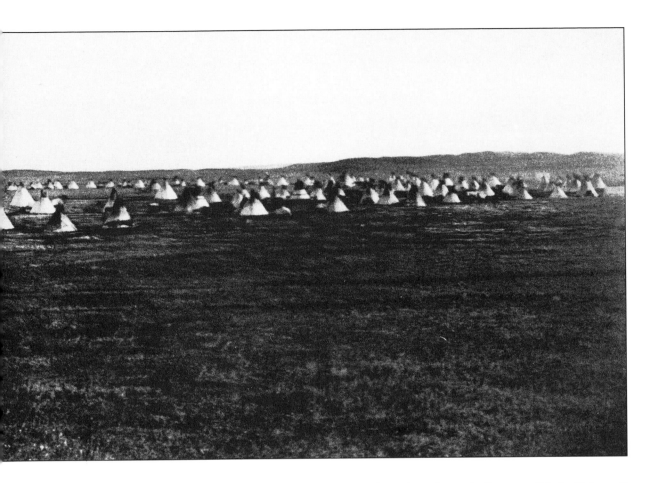

His chance came the next summer when his friend George Bird Grinnell wrote to see if he would like to go with him to the Piegan Reservation in Montana near the Canadian border. Curtis took the train to Browning, Montana, and then switched to horseback. He and Grinnell rode across a plateau to a high cliff, where they looked down on an enormous circle—nearly a mile wide—of tipis. Thousands of Blood, Blackfeet, and Algonquin Indians were meeting to celebrate the Sun Dance, a complex ritual of thanksgiving and prayers for spiritual strength for the individual and the tribe.

Grinnell told Curtis to take a good look. He doubted that either of them would ever be lucky enough to see such a large assembly again.

"The sight of that great encampment of prairie Indians was unforgettable," Curtis wrote. "Neither house nor fence marred the landscape. The broad, undulating prairie stretching toward the little Rockies, miles to the West, was carpeted with tipis."

Whites had outlawed the Sun Dance, not understanding its true significance. Curtis, who witnessed the ceremony for the first time, called it "wild, terrifying, and elaborately mystifying."

On another trip a few years later, Curtis witnessed the Sun Dance performed by the Arikara, another tribe of the plains; that time he described it in detail. The ceremony was initiated when an individual or the entire tribe wished to appeal for spiritual strength or to promote virtue. When a man decided to give this dance, he first went among the people of the village and asked for arrows. These were purified by the priest of the ceremony and used on a special buffalo hunt. When a buffalo was killed, it was ceremonially butchered and the skin was prepared for the ceremony.

Next, four special warriors were selected to locate a straight tree with a forked top. The entire village, with everyone wearing his or her finest clothing, traveled to see the tree and watch it being cut. After the lower branches were trimmed, young men lifted the heavy green pole and carried it to the center of the village. Young women gathered bundles of willows to create a shelter in which the Sun Dance would be held.

After purification ceremonies in a sweat bath, the priest and his assistants prepared the pole. Branches from chokecherry were tied to the ceremonial pole to represent an eagle's nest. From this was hung the buffalo skin, head downward, "so that the spirit of the buffalo might look down and impart its strength at the dancers." As the pole was raised and fitted into a special hole, a dancer with an eagle-bone whistle moved his arms like an eagle.

Dancing, singing, and praying continued around the pole. The climax of the ceremony took place on the last two days. Curtis wrote:

On the morning of the third day, such participants as wished to do so went to different places on the prairie, where each individual was pierced through the muscles of his back by an old man previously engaged by him for that purpose. Skewers were inserted, and to them were tied with thongs a number of buffalo-skins. The sacrificer, moaning and crying out, then dropped the skins into the dance-lodge, around the village, and back to the starting point, where his sponsor withdrew the skewers. . . . About noon of the fourth day the priest . . . stood opposite the pole. Such dancers as

42

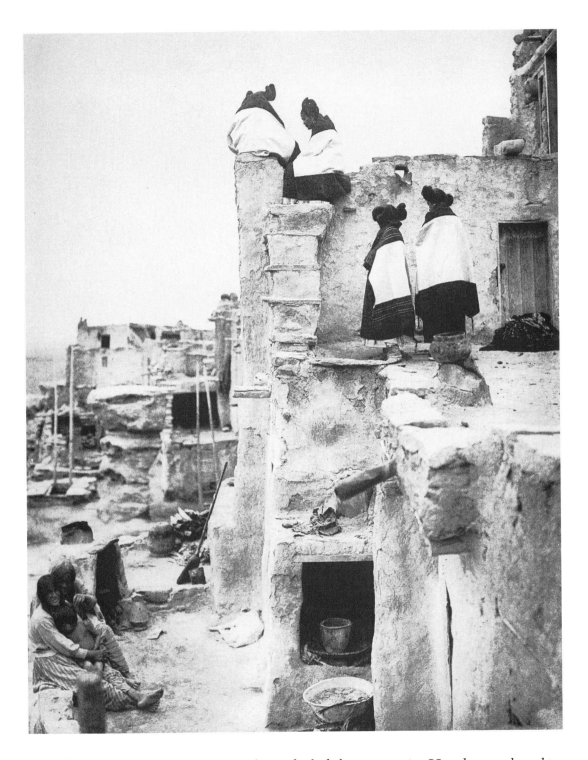

The central foreground of this photograph reveals the baking room of a Hopi house, where thin corn bread, called piki, *is prepared.*

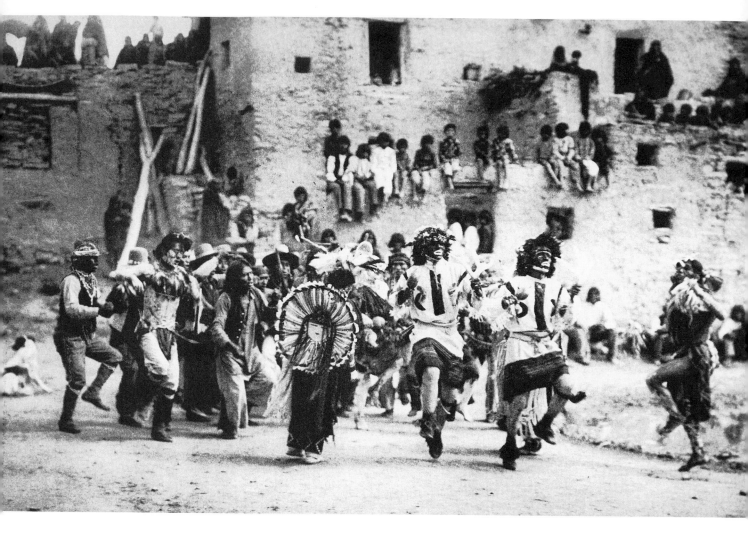

Buffalo Dance of the Upper Rio Grande pueblos is performed by Hopi.

remained steeled themselves for their final effort of endurance. Joining hands as the priest waved his buffalo-tail fan about his head as a signal, they ran around the pole, each until he fainted from sheer exhaustion.

When the dancers were revived, they described their visions, which were considered very important.

Curtis's experience in Montana made a deep impression on him. Only ten days after returning to Seattle, he was on the road again. This time he headed for the Southwest, "my first trip to Hopi land in Arizona." The Hopi main-

tained many ancient customs. They led "a life exceedingly rich in religious ceremony . . . ," Curtis wrote, "while their astronomical and astrological lore is even today a thing of wonder." The Hopi lived in "communal structures of stone, cliff-perched." The land received little rain and was unappealing to many white farmers. For centuries, the Hopi had been left alone to continue their religion and traditions.

Songs were sung for every job of the day. There were melodies for gathering water and for grinding corn. Curtis soon learned how important these songs were when he tried to record some of them on the wax cylinders. "Once a group of women were singing the songs that I might make a record of them. A neighboring woman came in anger to the door, asking, 'Why do you sing the songs of before the sun comes at the hour when the sun is half spent? The gods will be angry with you.' "

Songs were sung at nightfall, too. "Low songs in the caressing tone of the Hopi float out on the still evening air," Curtis recalled. "The very atmosphere seems to breathe of contentment, and one has but to close his eyes to the few things of modern life which have crept in to feel that this is as it has been for untold generations."

When Curtis returned to Seattle, he busily experimented with the motion-picture camera, a brand-new invention. He dabbled in gold mining and wrote articles for professional photography magazines. While absorbed in these new interests, Curtis may not have been prepared for a major turning point in his life during the year 1900. Asahel, who had been prospecting in the Klondike, returned to Seattle. He immediately announced that he wanted ownership of all the Alaska negatives that he had taken. Curtis refused. The negatives belonged to the studio, he said.

Out of their dispute grew a tragic bitterness between the two talented brothers. For the rest of their lives, a wall of silence separated them. Ellen Curtis and her daughter Eva, Edward's sister, eventually moved out of Edward's house and sided with Asahel. In years to come, Edward's children never met Asahel's, even though they grew up in the same town.

This stubborn feud had unforeseen consequences. Edward Curtis was cut loose from some of the heavy family responsibilities he had shouldered for so long. With his new freedom, he would wander farther and farther from home.

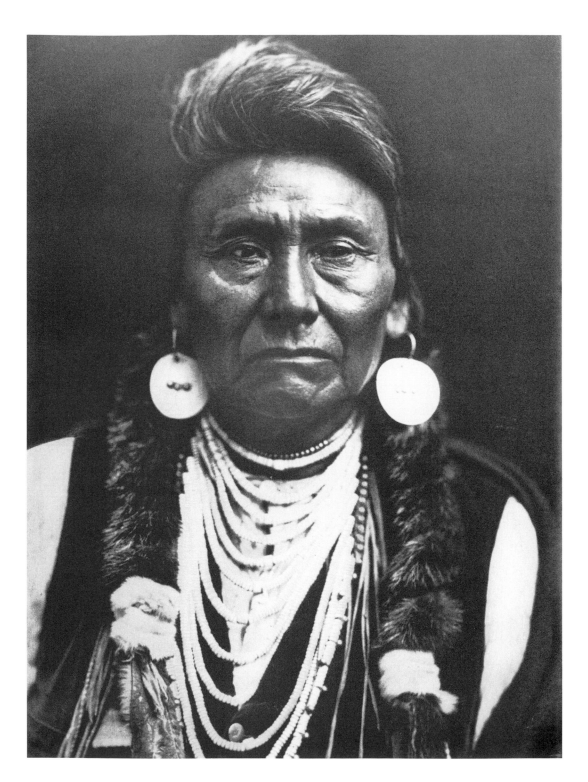

Chief Joseph—Nez Percé.

CHAPTER FOUR

In 1903 the Curtis studio had a surprise visit. Chief Joseph of the Nez Percé tribe arrived at the door with his nephew, Red Thunder, and Professor Edmond S. Meany of the University of Washington. The three men were in Seattle to give a lecture calling for the return of the Wallowa Valley, Oregon, the Nez Percé homeland. Would Mr. Curtis take their picture?

Sixty-three-year-old Chief Joseph was one of the most famous leaders of his day. He often wore a feathered war bonnet as he sat in a chair beside Meany. Because the professor insisted on standing, it's difficult from the photograph to appreciate Chief Joseph's true size—six feet two inches in his bare feet, and a solid 200 pounds. He stared straight into the camera, unsmiling, yet dignified. The fearless, imperial-looking portrait fit his nickname, the "Indian Napoleon." Newspapers had given him the name because of his bravery and military genius.

In 1877, when he was thirty-seven years old, Chief Joseph became the symbol of Nez Percé resistance. He outwitted 2,000 U.S. soldiers with 250 warriors and 450 women and children. In eleven harrowing weeks, the Indians dodged soldiers for 1,700 miles—from Idaho to northern Montana—and won thirteen battles against incredible odds.

Only forty miles from freedom in Canada, where they would have been protected by the Canadian government, Chief Joseph and his followers were captured and forced to surrender. "I am tired of fighting," he said. "The little children are freezing to death. My people, some of them, have run away to the hills and have no blankets, no food. No one knows where they are—perhaps freezing to death. Hear me, my chiefs! I am tired. My heart is sick and sad. From where the sun now stands, I will fight no more forever." Chief Joseph and his ragged, starving band were imprisoned at Fort Leavenworth, Kansas Territory, until 1878 when they were exiled to reservations in Oklahoma and, later, in Washington state.

After he took Chief Joseph's picture, Curtis spent a great deal of time talking with "the splendid old chief," whom he later called "the most decent Indian the Northwest has ever known . . . one of the greatest Indians who ever lived."

Just a year after the photograph was taken, Chief Joseph died. The reservation doctor listed as the cause of death "a broken heart." Curtis attended his funeral. Later, he helped rebury his friend in Nespelem, Washington, on the Colville Indian Reservation where his remains were placed under a seven-and-one-half-foot-tall white marble monument inscribed with Chief Joseph's Indian name, Hin-mah-too-yah-lat-kekht: Thunder Rolling in the Mountains.

Whether Curtis realized it at the time or not, his encounter with Chief Joseph showed the direction his life would take for the next thirty years. Not only would he seek to capture Indians' images on film, he would also collect as much information as he could about their way of life before the coming of white men.

No lightning struck. No bells rang. Curtis's vision came slowly, gradually as he built up his collection of Native American photographs and research. By late 1903 or early 1904, he knew what he wanted to do. He planned to systematically record in photographs and words the lore of tribes that, he felt, "still retained a considerable degree of their customs and traditions." Using the field techniques he had learned from Grinnell and others on the Harriman expedition, he would combine art and science to provide something beautiful and informative, haunting and invaluable for both experts and the public. He hoped that his work would guarantee that the Indian would not "by future generations be forgotten, misconstrued, too much idealized or too greatly underestimated."

It was an enormous undertaking and risk. Just the kind of challenge Curtis liked.

From 1900 to 1906, he spent less time in the Seattle studio than he did in the field taking pictures of Indians. The family portrait business was critical in funding his lengthy trips to the Southwest, the Rockies, and the High Plains. Curtis kept quiet in the beginning about any plan to create "a great project," instead of seeking publicity as he had for the earlier Klondike gamble.

Key to his ability to be away so much of the time was an inspired staff and

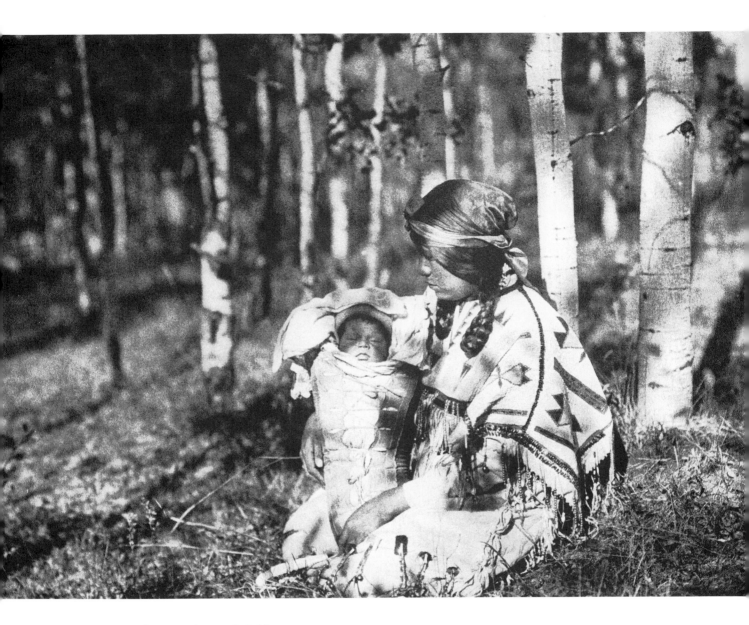

An Assiniboin mother and child.

a dependable, talented studio manager named Adolph Muhr. Hired in 1904, Muhr was the first Curtis employee who wasn't a member of the family. A well-known photographer's assistant, Muhr had helped take more than 1,000 images of thirty-six tribes as part of the Trans-Mississippi and International Exposition in 1898. He knew firsthand the difficulties and challenges Curtis faced. For the next nine years, Muhr and an assistant processed and printed all

Zuni girls at the river.

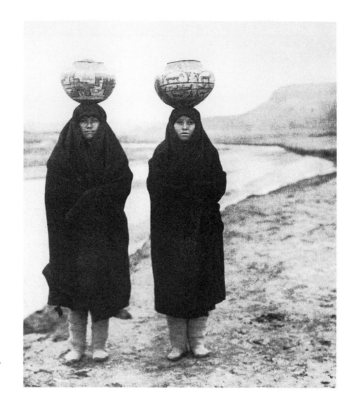

of the negatives Curtis sent from the field. His technical expertise was often critical in handling negatives that needed retouching or appeared too dark. Curtis did not exaggerate when he called Muhr "the genius in the darkroom."

Like other studio employees, Muhr often worked long hours for uncertain pay. Even when the Chief, as Curtis was called, was out of town, he had a way of inspiring his staff to do its best. "Curtis himself is the most tireless worker that I have ever known," Muhr wrote, "and his example is so contagious that everyone connected with him seems fired by the same enthusiasm and imbued with the same energy and ambition to do things and accomplish the work laid out for him."

During these critical early years, Curtis's energy and ambition were fueled by applause from an ever-widening public. He had the good fortune to have made friends in high places—people who helped his work become known locally and nationally.

His first display of "the latest images of the Mojave, Zuñi, Supia and Apache" took place in the Curtis Studio in 1903. The following year, he hired a hall in Seattle for his Indian pictures of the Piegan encampment in Montana. The crowd loved the photographs, and the newspapers gave him glowing reviews. He was invited to speak at the Rainier Club to show 150 "lantern slides"—projected and enlarged versions of his photos. This was followed by an engagement with the Mazamas Mountaineering Club.

In 1905 he went on the road with his Indian photos. His Alaskan expedi-

tion benefactor, Edward Harriman, helped set up a show at the fashionable Washington Club in the District of Columbia, which led to appearances at the Cosmos Club and the National Academy of Sciences. Emboldened by his success, Curtis rented a large room at the Waldorf-Astoria in New York City and invited wealthy members of society to see his work. Among those who made purchases was Louisa Satterlee, the favorite daughter-in-law of Wall Street financier J. Pierpont Morgan.

So much attention from millionaires and men of letters exhilarated Curtis, who remembered all too keenly his own childhood poverty and lack of schooling. But it was undoubtedly an invitation from President Teddy Roosevelt that thrilled Curtis most of all. In the summer of 1904, he was asked to come to Sagamore Hill, the Roosevelt summer home in Oyster Bay, New York. President Roosevelt had seen Curtis's winning photograph in "The Prettiest Children in America" contest published in *Ladies' Home Journal*. As the proud father of four boys and two girls ranging in age from seven to twenty, he wanted Curtis to take portraits of his children, too.

Roosevelt's children were not the easiest subjects to photograph. They had been dubbed "the White House Gang" because they liked nothing better than to ride their pony in the White House, roller-skate on the wooden floor, and clump up and down the steps on stilts. Fortunately, Curtis got some good shots and the visit was a success.

The tall, self-assured photographer from the West made a favorable impression on Roosevelt. Although he had been raised in wealth and comfort in the East, the president considered himself a westerner at heart.

When Curtis told the president about his western Indian photographs and showed him examples of his work, Roosevelt was very moved. "I will support you in any way I can," he said.

Thanks to Roosevelt, Curtis returned to the East Coast in March 1905 to meet another famous man. He was invited to Carlisle, Pennsylvania, to take a picture of Geronimo, a Chiricahua Apache warrior whose very name had once inspired terror in southern Arizona, New Mexico, and northern Mexico. Now seventy-six years old, Geronimo was to ride horseback with five other chiefs in Roosevelt's splashy inauguration parade in Washington, D.C.

Geronimo had been living under heavy surveillance at Fort Pickens, Florida,

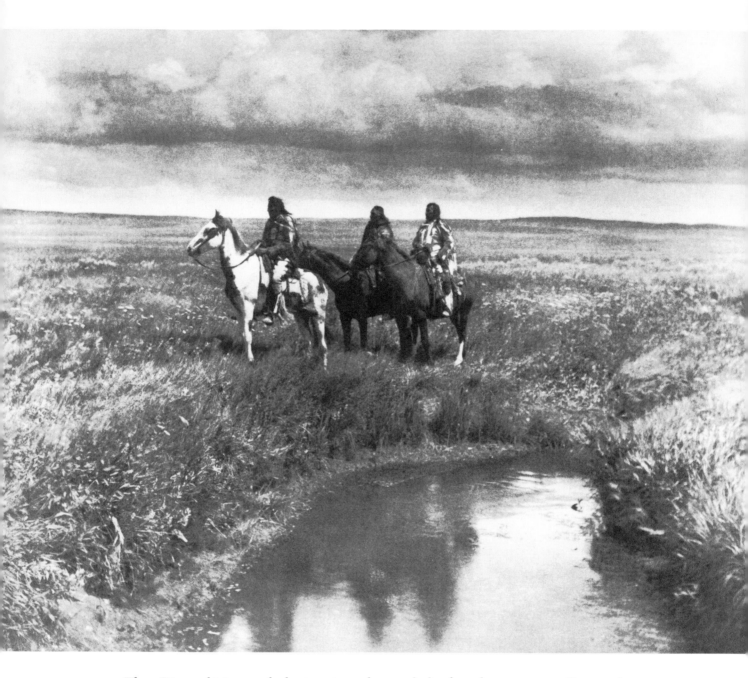

Three Piegan chiefs scan the horizon in a photograph that brought attention to Curtis when it was exhibited in Seattle, Washington, D.C., and New York during 1904 and 1905.

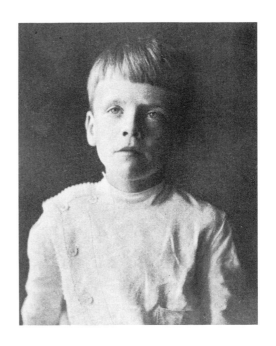

and later at Fort Sill, Oklahoma, for nineteen years. He was described by one observer as a weary, quiet man, nothing like the young fighter who had led a small band of Apaches in resistance. Geronimo began his series of notorious raids after discovering the dead bodies of his mother, wife, and three children, who had been massacred by Mexican troops. For twenty-five years, Geronimo led armed guerrilla resistance until he was captured and forced to surrender in 1886. On the day of Roosevelt's inauguration in 1905, the once-feared Apache warrior, now frail and wrapped in a bright red blanket, trotted down Pennsylvania Avenue in the drizzling rain. Geronimo's days were numbered. He had less than four years to live. His death, like Chief Joseph's, only prompted Curtis to work even harder.

There was not a moment to lose. "The passing of every old man or woman means the passing of some tradition, some knowledge of sacred rites possessed by no other," Curtis insisted. "The information that is to be gathered for the benefit of future generations, respecting the mode of life of one of the great races of mankind, must be collected at once or the opportunity will be lost for all time."

Curtis felt so strongly about the urgency of his project that for six years every penny of the work's cost came out of his own pocket. As a former engraver, he had high, often expensive standards. His work had to be printed in a large, magnificent format using acid-etched copperplates. Only the finest paper would do.

All this cost money, and Curtis soon found that his pockets were becoming

empty. The project had placed tremendous financial strain on his family. The Seattle studio was barely covering expenses and paying salaries to employees, even after Curtis managed to borrow $20,000 from friends. He was going to have to find outside funding to continue.

The problem was, where?

Although he had tried repeatedly, he could not convince any commercial publishers to reproduce his photos of Native Americans. ("The market's full of 'em," one New York publisher told him. "Couldn't give 'em away.") Curtis tried not to feel hopeless. In an unusually revealing letter to his friend, Frederick Webb Hodge of the Smithsonian Institute, he wrote:

"The longer I work at this collection of pictures the more certain I feel of their great value. Of course, in the beginning, I had no thought of making the series large enough to be of any value in the future, but the thing has grown so that now I see its great possibilities, and certainly nothing could be of much greater value. The only question now in my mind is, will I be able to keep at the thing long enough and steady work [sic], as doing it in a thorough way is enormously expensive and I am finding it rather difficult to give as much time to the work as I would like."

Desperate for cash, Curtis finally wrote to President Roosevelt in December 1906. Did he know anyone who might help back his project?

Roosevelt replied, "There is no man of great wealth with whom I am on sufficient close terms to warrant my giving a special letter to him, but you are most welcome to use this letter in talking with any man who has any interest

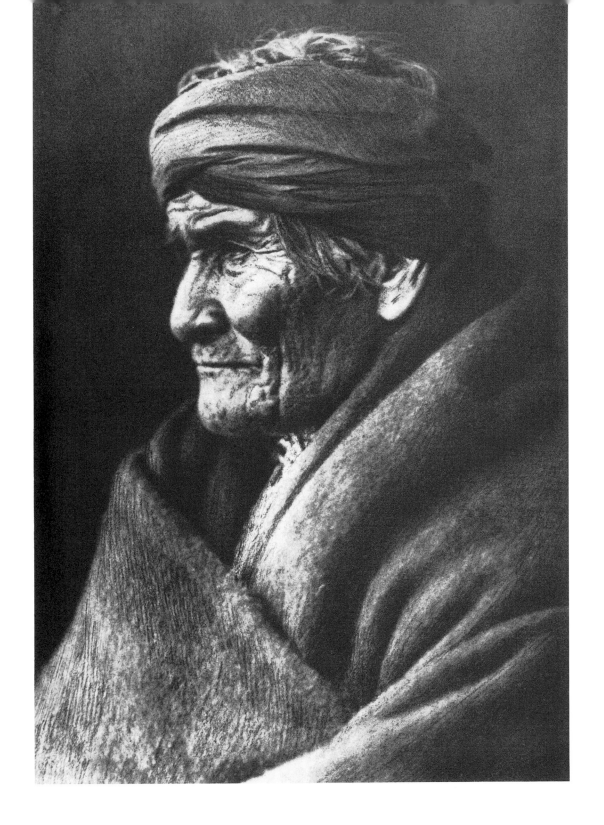

Apache chief Geronimo, 76, was photographed in Carlisle, Pennsylvania, prior to Roosevelt's inauguration.

in the subject." Roosevelt went on to add these words of encouragement: "The publication of the proposed volumes, and folios, dealing with every phase of Indian life among all tribes yet in primitive condition, would be a monument to American constructive scholarship and research of a value quite unparalleled."

Armed now with a letter of recommendation from the President of the United States, Curtis decided to take an extraordinary gamble. J. Pierpont Morgan was considered the most powerful man in the country. Although he had made his fortune as chairman of U.S. Steel and in ruthless railroad deals, he now considered himself something of an art collector. His favorite daughter-in-law had already purchased one of Curtis's photos. Perhaps she might help Curtis set up an interview.

On January 24, 1906, an appointment was scheduled. "When I call I will bring with me a few pictures," Curtis promised Morgan in a letter. "No one can form an idea of the work until he has seen the pictures themselves. I feel that the work is worthwhile, and as a monumental thing nothing can exceed it."

Curtis sounded spunky in his letter. But when he walked into Morgan's impressive, wood-paneled office on Wall Street, he probably had an attack of the jitters. And who wouldn't? There was the big, glaring man himself, seated behind his enormous teakwood desk. Morgan's piercing eyes were so overwhelming, one visitor likened them to "the headlights of an express train bearing down on you."

Curtis told Morgan of his plan to create "a broad, luminous picture" chronicling in words and photographs the "vanishing" way of life of more than eighty tribes west of the Mississippi. He explained how he planned twenty volumes containing 1,500 full-page plates. The accompanying text would include information about the Indians' history, life and manners, ceremony, legends, mythology and—

Morgan cut him off. Thank you very much, he said, but he was a busy man. His secretary would see Mr. Curtis to the door.

Mr. Curtis had no intention of leaving. Not yet. Not when he had come this far. He reached into his portfolio and spread photographs on Morgan's desk.

Morgan looked them over. He was not a man known to change his mind.

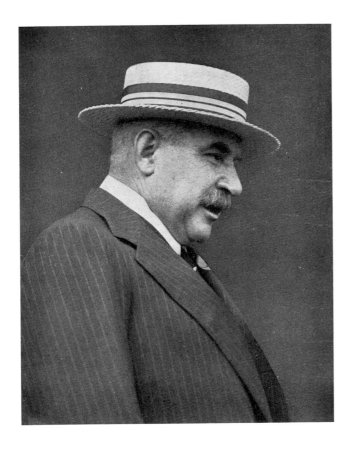

But something about the portraits grabbed his attention. He told Curtis that he wanted to see these photographs in "the most beautiful set of books ever published."

Morgan's words must have thrilled Curtis. His project was saved!

Morgan promised to give Curtis $15,000 a year for five years. The money wasn't a gift. It was a loan to cover the cost of fieldwork: three assistants' salaries, transportation costs, hotels, and fees for interpreters. This money was to be repaid in sets of finished publications and in royalties—a share of the proceeds from sales of the books.

In return, Curtis promised that in just five years he would create twenty volumes of text, each illustrated with about seventy-five small prints. Accompanying every volume would be an oversized "portfolio" of thirty-five photogravures created using the finest methods available and printed on imported paper with covers bound with Moroccan leather.

When Curtis asked who would research and write the text, Morgan replied that Curtis should do the job.

Curtis practically floated out of the Wall Street office, he was so happy.

However, almost immediately he was beset by problems. No commercial publisher was interested in the project, even with Morgan's partial backing. Without a publisher, there would be no royalties and no way to repay Morgan's loan.

Now what? Curtis went back to Morgan to explain the situation. Always

the businessman with an angle, Morgan did not seem discouraged. ("I like a man who attempts the impossible" was his motto.)

He convinced Curtis to publish the project himself. Become a salesman, Morgan said. Sell the twenty-volume set for $3,000, payable in advance as a "subscription." Use that money to pay back the loan.

Curtis hesitated. By accepting Morgan's plan, he would become not only photographer and writer, but salesman and producer, too—without any guaranteed salary. But he was flattered by the wealthy, important man's confidence in him. After all the other financial risks Curtis had taken, why would one more make any difference?

Curtis shook Morgan's hand in agreement. Exuberantly, he hurried back to Seattle, not knowing just how heavily this burden would weigh on him the rest of his life.

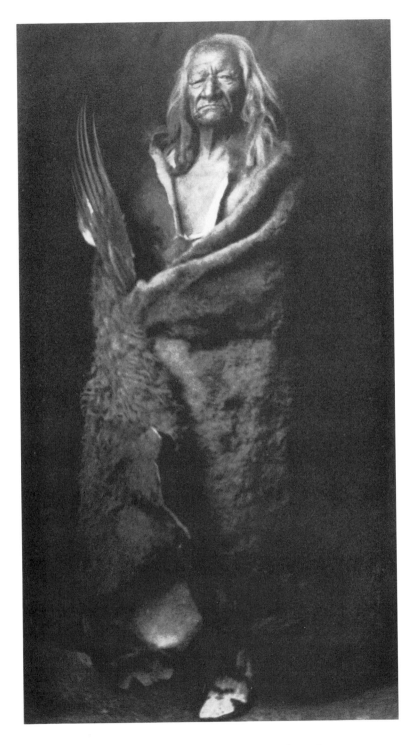

Assiniboin chief Black Eagle, born in 1834 along the Missouri River, first rode as a warrior with his tribe when he was thirteen.

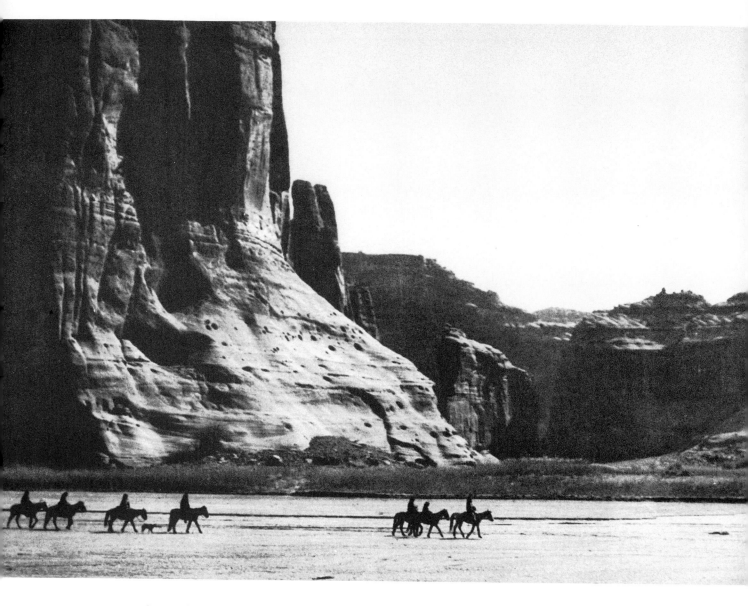

Sandstone cliffs tower over riders deep in Canyon de Chelly, the heart of Navajo country in northeastern Arizona.

CHAPTER FIVE

To get the project moving, Curtis needed a capable staff to help him. In 1906 he hired the respected expert Frederick Webb Hodge, of the Bureau of American Ethnology of the Smithsonian Institution, to work as his editor. Hodge was editor of *The American Anthropologist* and had experience in the field collecting information about Indians in the Southwest. For every 1,000 words Hodge was to be paid seven dollars. Another new key employee was William Myers, an affable young man with an English degree who was working as a newspaper reporter in Seattle. Myers had excellent shorthand and typing skills and an uncanny ability to take down rapidly, sound for sound, any language spoken to him.

With great enthusiasm, Curtis began organizing that summer's fieldwork among the Apache, Navajo, and Hopi in northern Mexico, Arizona, and southern Colorado. He was determined on this trip to uncover as much as he could about the inner life of the Apache, something many white ethnologists of his day simply believed did not exist.

The extensive list of field gear included a "motion picture machine," several cameras, glass plates, wax cylinders to record speech and music, a trunk of books, a tent, a typewriter, cooking equipment, enough food for several months, and files containing all the letters he would answer while away in the field. He also brought along an air mattress, which would later astound Hopi children so much that Curtis was named "the Man Who Sleeps on His Breath."

This trip would be different from any other Curtis had taken, because Clara and all the children were joining him. Harold, who was eleven, nine-year-old Beth, and seven-year-old Florence had never accompanied their father into the field before. They excitedly traveled by train from Seattle to Los Angeles and then on to Gallup, New Mexico, by horse-drawn covered wagon. Their destination was Canyon de Chelly, a thirty-mile-long canyon in northern

Arizona. In this canyon, less than fifty years earlier, Navajo who refused to be herded onto reservations were rounded up by Kit Carson and his U.S. troops. Carson ordered his soldiers to slaughter the Indians' cattle and burn their crops, including 5,000 peach trees. Nearly 8,000 Navajo were forced to march 350 miles to Fort Sumner, where they were imprisoned for four years. An estimated 2,000 died. The lucky ones escaped back to their canyon homeland.

On the Curtis expedition, there were hints of trouble from the very beginning. When the family stopped at a local trading post for supplies, they suddenly found themselves in a flash flood caused by a storm in the mountains. Water crashed through their camp. To keep from being swept away, Harold, Beth, and Florence scrambled to high ground with their mother. Curtis waded waist-high in swirling water to save the equipment, which fortunately had been packed in waterproof containers.

Once joined by an interpreter, the group traveled deeper into the canyon. All around them was the fragrant smells of piñon and juniper. The Navajo lived in hogans made of earth and wood. To farm, the Indians climbed down into the canyon, called "the garden of the reservation," where they grew corn and vegetables.

One day the canyon became strangely silent. "We were given strict orders not to leave camp," Florence remembered. "The quiet was broken only by the chanting of the medicine men, which echoed and reverberated until it became a ceaseless sound in the canyon."

Curtis did not tell his children how dangerous the situation had become. An Indian woman was having difficulty giving birth. The medicine men who were attending her blamed the problem on the presence of white people in the canyon.

"Pray that the baby will live," the interpreter told Curtis, "for there is no power on earth that will save you and your family if it should die."

Curtis did not intend to wait around for the baby's birth. He and Myers threw tents and equipment into the wagon, loaded the children and Clara, and hurried out of the canyon. Only years later did Curtis reveal how frightened and helpless he had felt. "I vowed then that never again would I include all the family on a trip into Indian country."

While his family returned to Seattle, Curtis and his assistants hurried on

Florence at Canyon de Chelly in 1906. (Reproduced with permission of James Graybill)

to finish work among the Apache, Navajo, and Hopi. Curtis's troubles weren't over. After the wagon had to be unloaded onto a pack train, one of the mules slipped and hurtled down a canyon wall. Curtis's best camera lay smashed and scattered. But Curtis did not give up. He collected the pieces and spent the next twelve hours fitting them together. Although the camera was held together with only a rope, it was operable the rest of the journey.

Work in the field was never easy. Harsh weather often confounded the most routine chores and the simplest movements. Curtis and his assistants faced torrential rains that changed their dry campsites into lakes overnight. In the darkness they sometimes had to grab their equipment and race for higher ground. If a fierce wind hit, it blew tents to the ground or whipped them to shreds. In sandstorms, nothing could be done but wait.

Temperatures often reached extremes. At times, the cold and snow could "cause you to forget you were ever warm." On other days, the heat seemed as intense as a furnace.

In spite of many physical hardships, the crew managed to have a very productive season. While visiting the Hopi in August, Curtis observed the spectacular sixteen-day ceremony called the Snake Dance, one of many sacred Hopi ceremonies.

Although Curtis had seen the Snake Dance in a Hopi village two years earlier in 1904, and had photographed outdoor parts of the ceremony with his "motion picture machine," it would not be until 1912, on a return trip to the Hopi, that he would be invited to participate in early preparation rites—something few white people had ever been invited to do before. These rites took place in a kiva, a special underground room. The Snake Dance rituals were carefully overseen by the elders of the Snake Society.

Throughout his career, Curtis's success depended on his ability to win the Indians' trust. "Tact, diplomacy and courage combined with a good stock of patience and perseverance" were absolutely essential, according to Muhr. Without these, Curtis would have failed, the way many other white researchers had before him. And Curtis was fortunate to be taking pictures of Indians while they were still willing to be photographed. In a few years, they would no longer comply, having grown tired of the herds of snapshooting white tourists.

For the time being, Curtis benefited from the Indians' curiosity.

Curtis called this Tewa image taken in the Southwest in 1925 "Offering to the Sun, San Ildefonso."

Word spread quickly about the "Shadow Catcher." Once tribespeople found out what Curtis was doing, he discovered, many were intrigued by his project. "Many of them are not only willing but anxious to help," he later said. "They have grasped the idea that this is to be a permanent memorial to their race, and it appeals to their imagination. . . . A tribe that I have visited and studied lets another tribe know that after the present generation has passed away men will know from this record what they were like, and what they did, and the second tribe doesn't want to be left out."

Most important, the Indians sensed that he genuinely admired them. "Indians instinctively know whether you like them or if you're patronizing them," Curtis later wrote. "They knew I liked them and was trying to do something for them."

Of course, Curtis made mistakes. Sometimes he called certain rites "superstitions." Sometimes he did not have enough accurate information about a particular tribe when he arrived on the scene. Languages and nuances among tribes varied widely. Not all interpreters were equally skilled or dependable.

But Curtis was a quick learner and doggedly went after what he thought was the most accurate, authentic information available.

He followed a cardinal rule many white researchers did not: The only way to participate in Indian ceremonies is to be invited. To that end, he was always a gracious guest.

When he ran into trouble, his life might hang in the balance. Several times he felt the whiz of bullets zipping past, shot by hidden gunmen. He knew what it was like to be suddenly surrounded by a menacing crowd, his camera view blocked. Once, when a charging Indian on horseback acted as if he would lean over and grab his camera, Curtis refused to budge. When an Indian pitched dirt at his lens, Curtis pulled a knife. Fortunately, the Indian backed away. Curtis's "unflinching courage, not yielding the least ground" only helped his reputation.

Among the Apache during the summer of 1906, he discovered that he needed more patience, tact, and courage than ever. The Apache had historically been nomadic hunters. They were excellent horsemen who traditionally did not settle in villages or farms like the Hopi or Navajo. They collected much of their food and supplies by raiding their Indian neighbors.

Over the years, many unfortunate stereotypes had developed about the Apache. Some white ethnologists and researchers claimed that the Apache were so "tough and ferocious," they had no religion. Curtis quickly saw that wasn't true. "The men rose at dawn and bathed in pools or streams that their bodies be acceptable to the gods. Each man in isolation greeted the rising sun in fervent prayer. Secretly shrines were visited and invocations made," Curtis wrote. "I realized, though, if I asked a single question or displayed any curiosity as to their devotional rites, I would defeat my purpose."

Curtis always felt that religion was "a profoundly private matter." If he could convince the Indians to discuss their spiritual views, he would have little trouble in making other discoveries. But how could he find out the meaning of Apache rituals and beliefs if they refused to talk to him?

Curtis approached the Apache, as he did all Indians, by acting himself. He did not try to "dress Indian" or "talk Indian." People generally sensed his sincerity. The Apache invited him to join them on a mesquite-harvesting expedition. They were picking the seed-bearing pods, which were eaten green or

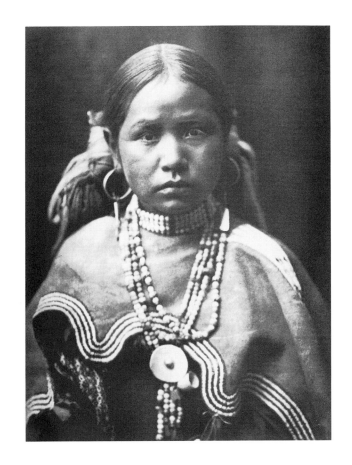

A Jicarilla girl wears her hair fastened at each side of her head with a large knot of yarn or cloth.

dried and ground. "That first night, with Indian courtesy they allowed me to pick my campsite first, which I chose by the river under the shade of a walnut tree. Around the campfire that evening we sat telling stories."

Although he listened carefully to the interpreter's version of the Apache prayers honoring the gods of the sky and the earth, the gods of the east, west, north and south, he remained confused. "I still had no key to this vast storehouse of primitive thought."

Six weeks passed. No information. Finally, he managed to convince one of the medicine men named Gosh-o-ne to tell him the Apache creation story. Gosh-o-ne told Curtis how in the beginning the earth was covered with water and all living things were below, in the underworld. Animals, trees, and rocks could talk. With help from the animals, the people discovered a hole that led to the upper world. To reach the hole they built four mounds of earth, which grew into mountains. Four storms rolled away the water into four oceans. The people climbed out of the hole, and each tribe traveled and stopped at different places that pleased them.

Later, another medicine man showed Curtis a buckskin prayer chart never before seen by a white person. The medicine man explained the painted symbols of the moon, the sun, and the four oceans. The chart was a document "beyond price . . . a miracle," Curtis wrote. "To us its greatest interest was the

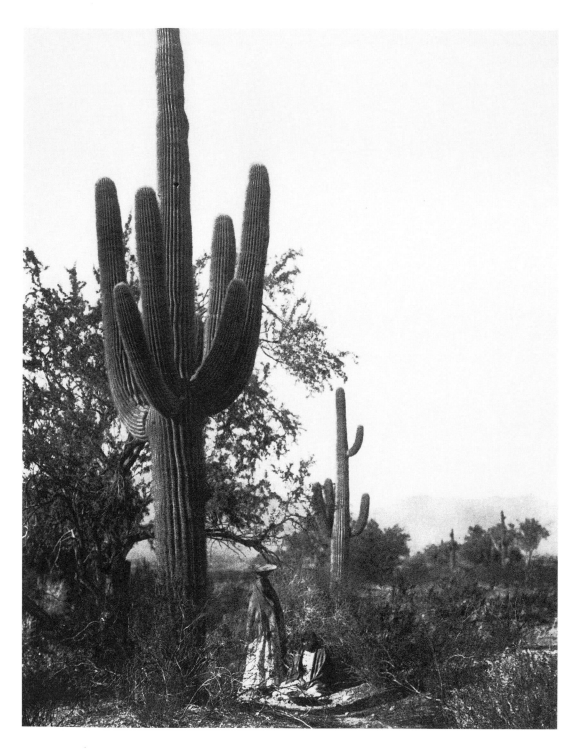

Pima Indians of southern Arizona use a long pole with a wooden blade on one end to gather the sweet pear-sized fruit of the saguaro cactus, an important food supply.

fact that its description confirmed every detail of the information secured from Gosh-o-ne."

Pleased with his success among the Apache, Hopi, and Navajo, Curtis moved on to fieldwork among the Walapai of Colorado. Curtis and his crew had to take a five-day journey down the Colorado River of the Grand Canyon in a crude steamship to find the tribes.

Myers proved to be invaluable. To the Indians, his skill seemed like "awesome magic." "An old informant would pronounce a seven-syllable word and Myers would repeat it without a second's hesitation, which to the old Indian was magic—and so it was to me," Curtis wrote. "At most times while extracting information, Myers sat on my left and the interpreter on my right. I led in asking questions, Myers and the interpreter prompted me if I overlooked any important points. . . . By writing all information in shorthand we speeded the work to the utmost."

Workdays were long. Every night after researching, Myers neatly typed all his notes. "Our average working time for a six months' season would exceed sixteen hours a day."

Another method used to capture the speech and songs of the Indians was the recorder invented by Thomas Edison. This machine recorded sound by using a needle to etch a wax-coated cylinder the size of a water glass. The Indian singers were awestruck when they heard themselves; they called the recorder "the magic box." In the course of his project during the next thirty years, Curtis would record a total of seventy-five languages and more than 10,000 songs.

When snow began to fall in December 1906, the season ended. The crew struggled with the wagon through the drifts and finally gave up. Now it was time to write the first two volumes. Curtis and his assistants gathered all their information and disappeared into "obscure rooms" in the Southwest to work on the text. Not even the Curtis family knew where they were as they worked for the next three months, seventeen hours a day.

Curtis polished the text for the first volume on the Navajo and Apache, which had been written that September. For every hour given to photography, he estimated, "two must be given to the written word picture part of this record." Once the first volume was finished, they began work on the second,

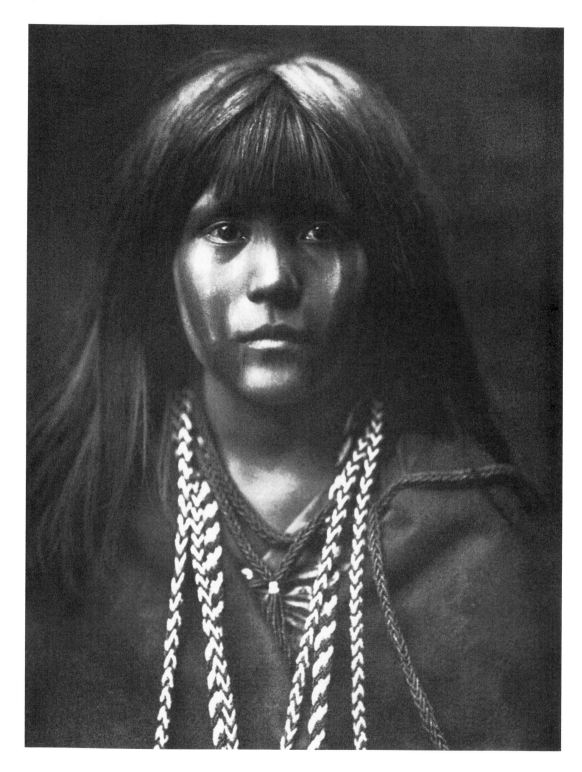

The questioning eyes of this Mojave girl of the Southwest seemed especially eloquent to Curtis.

which focused on nine tribes in Arizona, including the Pima, Papago, Mojave, and Walapai.

Curtis was happiest in the field, taking photographs and gathering information. This was what he loved best. But he soon discovered that the project was going to take far longer than the five-year estimate he had given Morgan. In 1907, he admitted that he was going to go two years past his deadline. And when would the entire project be finished? Curtis wrote, "When the Navajo does not know the answer, he says, 'Whoola,' which is perhaps the only answer. This I do know. That for six years more the work will be driven to the limits of endurance. After that there will be a little more leisure."

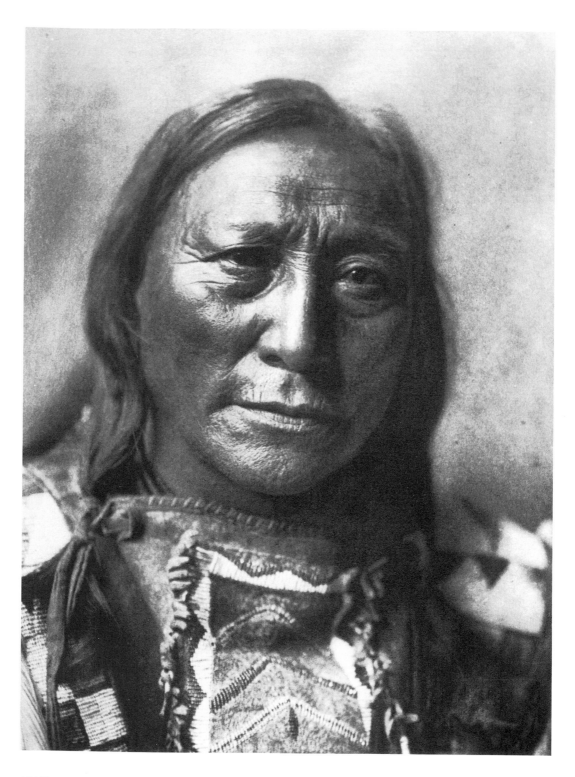

Hollow Horn Bear of the Brule Sioux, 1907.

CHAPTER SIX

Curtis crisscrossed the country—from Seattle to New York to Washington, D.C., to Boston and back again—at a breakneck pace. When he wasn't taking photographs or interviewing Indians, he was writing and editing, selling subscriptions, checking proofs, or placating creditors. And always, always he was urging on his staff: Faster! Faster!

The North American Indian, as the set of volumes came to be named, was far more difficult to sell than he had predicted. In 1907, financial panic gripped the country. The stock market took a nosedive and many companies went bankrupt. Not even wealthy individuals, or institutions like the Smithsonian, could be convinced to buy "subscriptions" in advance. Curtis struggled to find interested subscribers in spite of tough economic times. "Unfortunately for our feelings, at times, this book must be sold," he wrote Hodge, who patiently awaited his paycheck.

Selling subscriptions then became even more difficult: As Curtis learned from President Roosevelt in June 1907, "high-placed academics" in the new field of anthropology were seriously questioning his credentials. Who was this Mr. Curtis? they asked. Did he use scientific methods?

One account says that Curtis weathered this storm by presenting his field notes and interviews to a panel of experts, who examined the material and approved his work. But the experience haunted him. Now added to money worries were his own nagging doubts. How could he ever hope to please every academic, every important, learned person in every high place?

That summer Curtis and his crew headed for the Great Plains to visit the Sioux, Mandan, Arikara, Hidatsa, Apsaroke, and Atsina. Joining Curtis in the field for the summer were Clara and their son, Harold, called Hal. They had traveled by train and wagon to the dry, treeless reservation in western South Dakota. Life on the wide open plains seemed like high adventure to the thirteen-year-old, who would remember that summer for the rest of his life.

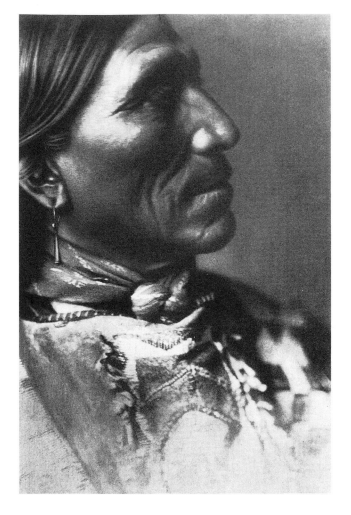

Brule Sioux Little Hawk.

Although restricted to reservations, the tribes of the Plains were expert horsemen and skillful hunters who used to spend part of the year living in tipis and following the buffalo—an animal that was both a food source and an important religious symbol. By the time Curtis arrived at the Pine Ridge Reservation in 1907, the massive buffalo herds had long since disappeared. All that remained were bleached bones. Sadder still was another memory, only seventeen years old. In 1890 the Pine Ridge Reservation had been the scene of the Wounded Knee Massacre.

Beginning in the early 1880s, Plains tribes in places like Pine Ridge had taken up the Ghost Dance, inspired by a Paiute visionary named Wovoka. Wovoka promised that if the Indians danced and sang, their dead relatives and disappearing way of life would return. So many Ghost Dancers assembled at Pine Ridge in 1890 that U.S. government officials feared an uprising. Approximately 3,000 soldiers were sent in to "keep the peace."

On December 29, 1890, a small band of starving Ghost Dancers camped along Wounded Knee Creek after being pursued over 100 miles by a group of U.S. Cavalry soldiers. The soldiers aimed howitzer cannons at the tipis. During a weapons search, one Sioux was thought to reach for a hidden gun. Rapid-fire shells burst among the Sioux. In less than an hour, the snow was covered with an estimated 200 dead or dying men, women, and children.

"After the soldiers marched away from their dirty work, a heavy snow began to fall. . . ." one Sioux witness later wrote. "The snow drifted deep in the crooked gulch, and it was one long grave of butchered women and children and babies, who had never done any harm and were only trying to run away."

Although the snows had come and gone many times since that sorrowful winter, the massacre on Wounded Knee Creek would never be forgotten.

Curtis arrived at the Pine Ridge Reservation in the summer of 1907. Chief Red Hawk and other Indian friends Curtis had made on another photography trip two years earlier warmly welcomed "the Shadow Catcher." Curtis had promised the Indians a feast, if they would set up rituals and battle scenes for his camera.

But instead of the twenty Indians Curtis had expected, more than 100 waited to be fed. Chief Red Hawk quickly lost control of the impatient crowd. They needed four cows, not two. No beef, no pictures, said the Indians. They sat on the ground and waited for their promised meal.

Curtis packed up his camera. No pictures, no feast, he said. He was leaving.

Wait, Red Hawk pleaded. After much argument, he persuaded the warriors to ride with him and another friend named Slow Bull into camp in two picturesque columns. Curtis took out his camera again.

In the evening after their feast, the Indians gathered around a campfire and told stories. Myers and the interpreter busily took down their words. As the Indians became more comfortable with the photography sessions, they often came into camp to visit. The Curtis tent became something like "a country store, as the Indians lounged about outside, the older men favoring the shady side," recalled Edmond S. Meany, who visited the scene.

Once he had won their confidence, several Sioux who had witnessed the battle of the Little Bighorn in 1876 offered to take Curtis and his interpreter to tour the battlefield, in southeastern Montana. The ride by horseback would take nearly two weeks.

The battle of the Little Bighorn, which had left 265 soldiers dead, was the turning point for the U.S. Army during the Indian Wars of the 1800s. After the battle, newspapers glorified the dead army leader. The flamboyant General George Armstrong Custer, with his long golden hair, cherry-red necktie, and velveteen jacket, became known as an ill-fated but courageous, all-American hero.

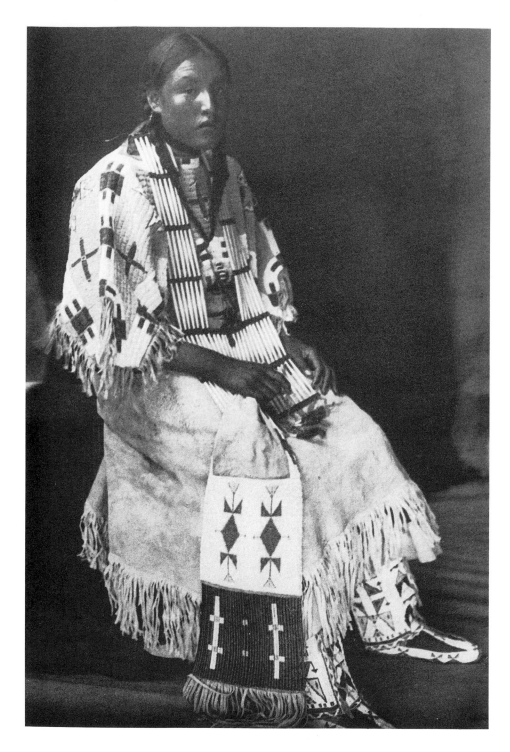

This Sioux girl's deerskin dress is beautifully embroidered with beads and porcupine quills.

Shot in Hand, an Apsaroke.

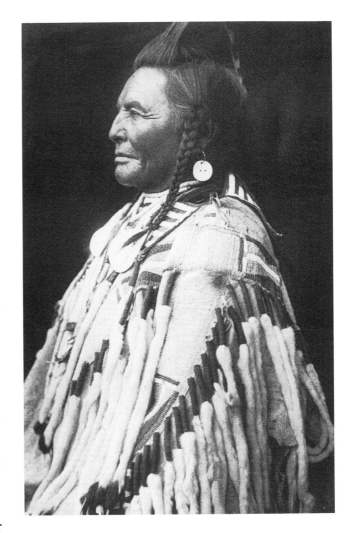

As Curtis roamed the buttes where "Custer's Last Stand" had taken place, he asked questions of Custer's three Crow scouts. What did White Man Runs Him, Goes Ahead, and Hairy Moccasins remember? Curtis interviewed Chief Red Hawk, who had also participated in the battle and recalled vivid details. The story Curtis now began to piece together was far different from the one popularized in newspapers, magazines, novels, and paintings.

No army account had ever before placed blame for the heavy loss of life on Custer's impatience, his lack of judgment, or his hunger for glory. Instead of waiting for reinforcements as he had been told, the Indians said, Custer ordered the 7th Cavalry straight into the encampment of 12,000 Sioux and Cheyenne. The battle lasted only an hour. Every single trooper was killed.

The Indians admired Custer's headlong daring, Curtis discovered. It was the kind of bravery emulated by warriors in proud military societies organized by almost every Plains Indian tribe. A member of one group of Crow soldiers considered extremely brave in battle was called "He That Wishes to Become Reckless Dog."

Curtis listened to old Indians recalling their way of life. One eighty-five-year-old Crow named Bull Chief was still "good for a forty-mile day in the

Two Moons was one of the Cheyenne chiefs present at the battle of the Little Bighorn in 1876.

saddle." Curtis considered him one of the best Indian storytellers he had ever met. Around the lodge fire, Bull Chief told Crow history that went back ten chiefs. He remembered how, as a young boy, he had killed buffalo calves with a bow and arrow. He recalled clearly the day he saw the first white man paddle

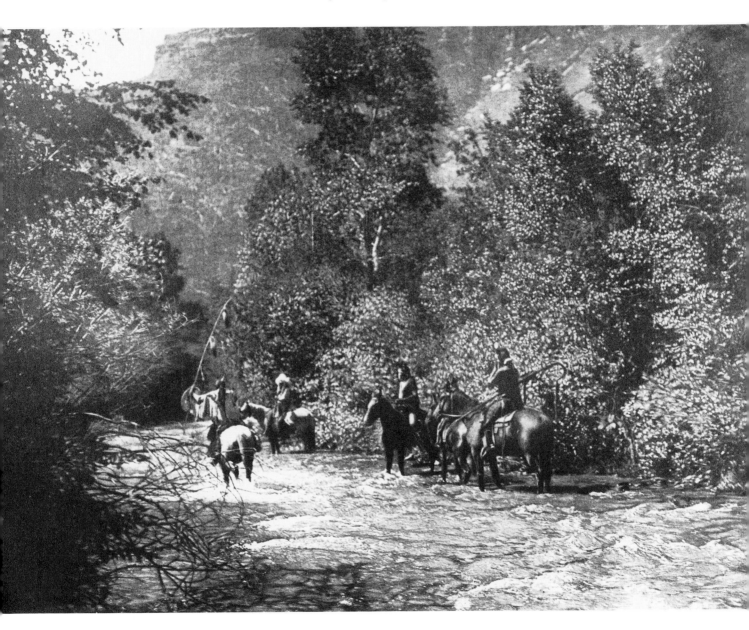

Apsaroke living in Montana follow a stream in an image Curtis titled "A Mountain Fastness."

a canoe to his family's camp on the Yellowstone River. Because the white man was tall and slender, the Indians called him Crane.

With so many good stories and photographs, Curtis was eager to be on his way to North Dakota to photograph the Mandan. But before they could reach the Indians on the Fort Berthold Reservation, near Bismarck, Hal came down with typhoid fever. For days the boy had tried to hide his condition. Only when he almost fell from his saddle did his father realize how sick he really was.

What should they do? There was no medicine for typhoid among their supplies. The nearest doctor was hundreds of miles away. To move Hal might be fatal. With every passing day, the end of the season grew closer. Soon it would be too cold and wintry to continue the fieldwork.

Curtis ordered the crew to North Dakota while he stayed behind with his wife and son. Hal was made as comfortable as possible on an air mattress beneath a tree. His mother gave him broth made from catfish and prairie chickens. He was sponged with water around the clock. But his fever would not break. Desperately, Curtis sent an Indian in a wagon twenty miles to the nearest railroad tracks to try to flag down the next eastbound train.

The Indian waited. He watched. In his pocket were money and a note asking the conductor to fill a prescription in Chicago. The medicine was to be dropped off at the same spot on the train's return run. After the Indian stopped the train, he waited for another week. Finally, Hal's medicine arrived.

"Hal was an ideal sick boy—as patient as anyone could be," Curtis said. In late August, when Hal was strong enough, he was loaded carefully on a wagon and driven twenty miles to the railroad tracks.

Curtis said good-bye to his wife and son. He would not see his family again until Christmas—nearly four months away. So much work remained to be finished in so little time. He had no choice but to stay in the field. As Curtis worked on harder than ever, he was too busy to notice the hairline fracture growing slowly between himself and Clara.

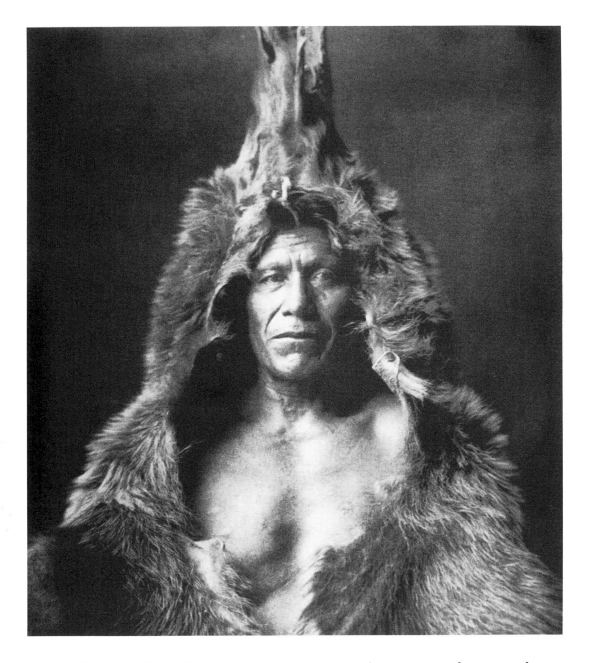

Bear's Belly, a member of the medicine fraternity of the Arikara, is wrapped in a sacred bearskin.

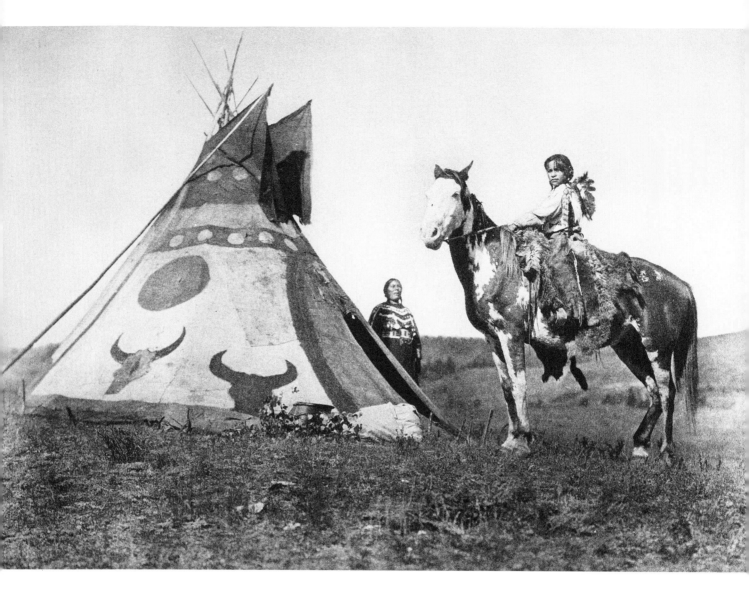

Assiniboins paint their tipis with figures representing images from dreams.

CHAPTER SEVEN

Curtis rushed to catch up with his crew, who were working with the Mandan Indians in North Dakota. Two hundred years earlier, a thriving population of 3,500 Mandan had hunted and farmed along the Missouri River. Nine fortified villages of earth-covered lodges served as major trading centers for Sioux and early white trappers. By 1834 an estimated 1,800 Mandan lived in villages along the high Missouri bluffs. Three years later a smallpox epidemic arrived on an American Fur Company steamer along with a shipment of passengers, food, and clothing. By the end of 1837, only 150 Mandan were left alive. Since 1870 they shared Fort Berthold Reservation with the Hidatsa and Arikara.

When Curtis arrived on the reservation, he discovered many abandoned earth lodges, which had once been inhabited by as many as twenty members of an extended family. A typical lodge, nearly sixty feet wide, was constructed with a timber framework and covered with a dense mat of willow twigs and dry grass. The last outer layer was made from hard-packed earth.

Curtis interviewed the oldest Indians to try and find out about the early Mandan way of life and religion. An individual named Packs Wolf, described in one account as "a renegade medicine man" who later reportedly converted to Christianity, told Curtis that he would secretly show him a sacred set of turtles if Curtis would pay $500 and undergo a purification ceremony in a sweat lodge.

The Mandan sweat lodge was a small dome-shaped framework of willow wands covered with blankets. Before entering, all participants removed their clothing. "We sat on our haunches with our backs to the blanket wall," recalled Curtis. "Before us was a shallow pit into which an attendant dropped hot rocks. The blanket opening was lightly closed and the singing began." Water was thrown on the rocks; the air filled with steam and the little shelter became hotter and hotter.

Curtis was advised by his interpreter not to lower his head or raise the edge of the blanket to cool himself. This was considered bad form. After four songs, the sweat bath ended.

Curtis was very nervous as he entered the dimly lit room in a log house where the sacred turtle drums were kept on a table covered with many offerings: strips of calico beads, pouches, plants, feathers. "The [Keeper of the Turtles] in a hushed voice rendered a short prayer to the Turtles, begging them not to be offended," Curtis wrote. "He next removed the mass of offerings under which the Turtles were buried so that I had my first glimpse of these mysterious objects. The Turtles were actually turtle drums and beautifully constructed." The Mandan believed that the spirit of a giant turtle resided in each drum.

According to the Mandan creation story, the first person on earth was called One Man. One Man wanted to teach all the other people a special dance that would help make them strong. The only creatures he could find sturdy enough to serve as his drums were turtles the size of islands. Because the turtles were too heavy to move, One Man went home, fashioned buffalo-skin drums in their shape, and invited the spirits of the giant turtles to crawl inside the drums.

Curtis photographed the sacred turtles. "The fear of interruption before the pictures could be made was a nerve-wracking experience," he later wrote.

Curtis and his crew left Fort Berthold and hurried to a secluded cabin in Montana to begin writing the next volumes of his work, about the tribes of the Rocky Mountains and Great Plains. Although he was far from the day-to-day sales operation, Curtis received regular financial reports. He knew that bills from the printer were coming in more quickly than subscriptions. Morgan's money was stretched as far as it could go, and still it only paid for a third of the necessary field expenses. The future of *The North American Indian* looked bleak, but Curtis refused to give up. "If you hear anyone say I am not to succeed tell them they don't know me," he wrote to his friend Meany. "Remember I am doing the best I can and keeping 17 helpers from getting cold feet and at the same time getting together something over forty-five hundred dollars a month to pay the bills." The seventeen helpers included Curtis's staff and the publication employees in Boston, New York, and Washington, D.C.

The first two volumes of *The North American Indian* were finally published in April 1908. President Roosevelt, who contributed the foreword, wrote: "The Indian as he has hitherto been is on the point of passing away. . . . It would be a veritable calamity if a vivid and truthful record of these conditions were not kept."

Curtis was thrilled with reviewers' reactions when the first volumes appeared. It must have seemed to him as if his hard work was finally paying off. One magazine called him "a poet as well as an artist." Another reviewer compared the beauty and completeness of the first two volumes of *The North American Indian* with the masterpiece of John James Audubon, *The Birds of America*, published between 1827 and 1838. Francis Leupp, the commissioner of Indian affairs, wrote: "Mr. Curtis's harvest has passed far beyond the statistical or encyclopedic domain; he has actually reached the heart of the Indian and has been able to look out upon the world through the Indian's own eyes."

Curtis's family was undoubtedly delighted to finally see the first two volumes in print. But his long absences and the endless financial strain of the project were beginning to take their toll. During all of 1907, he had not been in Seattle for more than a total of six weeks. The grinding schedule for 1908 promised even fewer visits home. Because he received no salary while he was working on *The North American Indian*, there was often little extra cash to buy "niceties" or the kind of furniture most of the Curtises' Seattle neighbors took for granted.

Clara's numerous relatives were openly critical of her husband's "unreliability." She often had to defend what he was doing. During the early years of the project, she tried to keep up a cheerful, bright outlook, at least in front of the children. Years later, Florence and Beth remembered how as little girls they used to excitedly wait for sight of their tall, handsome father walking up Queen Anne's Hill. But more often than not, he never appeared. Some last-minute emergency always seemed to prevent his return.

On those rare visits when Curtis did arrive for a holiday, he displayed great affection. "These were always such very special occasions," Florence remembered. But his time with his children never lasted long. "At home in Seattle he was either searching for data, getting equipment and material ready for the field trip or improving on his processes of photography and printing. And

Florence, Harold, and Beth with their mother, Clara Curtis. The Curtises' last child, Katherine, had not been born yet. (Reproduced with permission of James Graybill)

when we thought he might be coming home, he was in New York getting money or looking after the details of book publishing. We always said he had no home life at all."

By the summer of 1908, what little home life there was began to crumble. Hal, now fourteen, was sent to the East Coast to live with a rich, childless couple Curtis had met through Roosevelt. Curtis may have hoped the couple would provide Hal with educational advantages and career connections unavailable in Seattle. By the following winter, Hal would move east permanently. "I didn't see my sisters again for years," Hal wrote later. "I never came home because it wasn't really a home after [I left]." Hal's absence was undoubtedly hard on Florence and Beth. Their brother had cooked and cared for them

while their mother, reportedly, was out enjoying "a steady round of civic and charitable activities."

On July 28, 1909, a new baby, Katherine, was born to the Curtis household. It was too much to hope that little Billy, as she was nicknamed, would somehow heal the Curtises' rapidly deteriorating marriage. Soon after his fourth child's birth, Edward Curtis moved out of the family home for good. Although he visited his daughters whenever he returned to Seattle, he always gave his address as the Rainier Club, where he rented a room. Edward and Clara were now legally separated. Their situation was certainly considered scandalous in an era that frowned upon divorce.

Family strife, money worries, and hopelessness hounded Curtis. And yet he still managed to continue taking beautiful photographs. Through sheer determination, volumes three, four, and five were published in 1908. *The North American Indian* was just two years away from the 1911 deadline, when Morgan's money would run out. Fifteen more volumes and accompanying portfolios had to be finished in the short time remaining.

Collections from sales remained "heartbreakingly slow." Even though many readers admired *The North American Indian,* few could afford it. Curtis owed everyone money. Worse yet, his connection with Morgan was proving to be a real liability. Those who had enough money to buy the books "looked the other way and exclaimed, 'Oh! That is Mr. Morgan's affair and let him do it,' " Curtis said. Having a powerful, wealthy man as a patron hurt Curtis in other ways as well. Many institutions, museums, and universities were suspicious of his work because of the famous financier's connection.

Desperately, Curtis decided to try to market the project in England. He hoped to convince a prominent British scientist to review his book and promote sales overseas. Alfred Cort Haddon, of Cambridge University, was a respected anthropologist and lifelong photography enthusiast. Would he like to come along on fieldwork among the Blackfeet in Montana?

Haddon, reluctant at first, agreed to join Curtis during the summer of 1908, intending to stay for only a few days. But the visit soon stretched into several weeks. Haddon declared himself "much attached to Mr. Curtis," whom he described as "essentially an artist" who used his camera and only "fresh [written] observations" to record Indian peoples' ways of life. Haddon, a

proper fifty-three-year-old Englishman with a mustache and wire-rimmed glasses, found Curtis's fieldwork fascinating. Haddon was even a good sport when "parboiled by puffs of steam" in a purifying Blackfoot sweat bath.

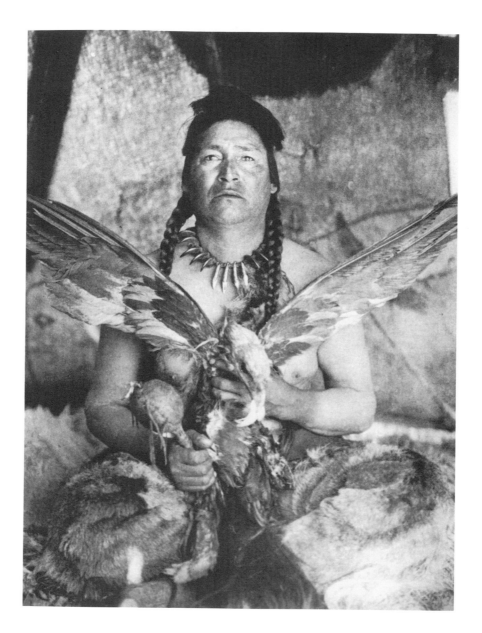

Assiniboin hunters hid in brush-covered pits to catch eagles, whose feathers are prized. To thank the eagle spirits, a special ceremony takes place over the bodies of the slain birds.

The sweat bath was necessary in order for Curtis, Haddon, and the rest of the crew to participate in a Blackfoot Medicine Pipe ceremony, which was believed to come from Thunder. The ceremony gave individuals a chance to give thanks to the Great Spirit for helping them recover from illnesses and other misfortunes. Haddon described the pipe used: "Ten eagle feathers are suspended along its length, and it is furnished with a tassel of cords, bound with bands of dyed porcupine quills and a lock of human hair."

The Medicine Pipe ceremony took place in the painted lodge of a man named Wild Gun. The lodge was painted black and buff and adorned with a blue buffalo head and a blue elk head and feet. Every space was taken by men, women, and children wearing their finest dress. A small charcoal lamp glowed near the central fire pit. Pungent purifying smoke from burning sweet grass wafted toward the smoke hole in the ceiling. The air rang with the sounds of praying, chanting, and the rhythmic shaking of gourd rattles.

The Blackfeet passed around sacred buffalo stones, which were treasured spiral-shell fossils. The first buffalo stone was said to have been discovered by Weasel Woman long ago during starving times. The stone taught her the songs and ceremonies that would ensure her people abundance on the buffalo hunt.

These special ceremonies and rituals were still an important part of the Blackfoot way of life. After the feast was completed, the Indians took part in a Medicine Pipe dance. The sacred pipe was reverently removed from its bundle and passed from dancer to dancer. "Just before it became my turn to dance with the medicine pipe in my hands, my informant told me that it would be very unlucky if I tripped or if any feather or other decoration of the pipe fell off, and cautioned me to be careful," Haddon later wrote. "Fortunately, neither calamity happened." Haddon, like Curtis, was very struck by the Blackfeet's "intense religious feeling."

Curtis was disappointed when he went to New York in November 1909 and could not convince Morgan to give Haddon one of the few copies available of *The North American Indian* for his own personal use. Consequently, Haddon never wrote the favorable review that Curtis had hoped for. But the Englishman's memories of that trip across the prairie "redolent with the scent of the sagegrass" and his adventures among the Blackfeet would remain vivid as long as he lived.

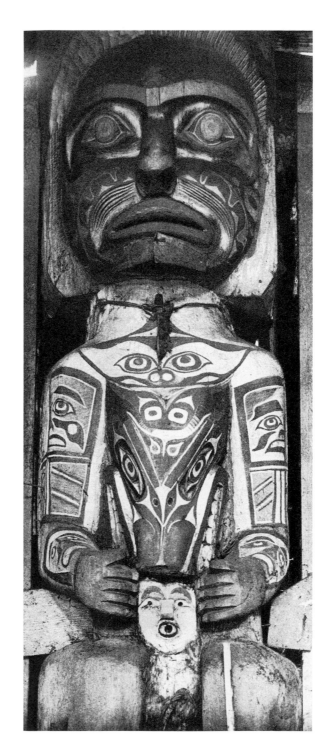

*An enormous carved interior column in a
Kwakiutl house helps keep alive family legends.*

CHAPTER EIGHT

Curtis made big plans for the spring of 1910. He decided to travel up the Columbia River to the Pacific, following the same 1805 route as the Lewis and Clark expedition, then north along the northwest coast of Washington and Canada. "I wanted to see and study the region from the water, as had Lewis and Clark more than a hundred years ago," Curtis wrote. "I wanted to camp where they camped and approach the Pacific through the eyes of those intrepid explorers."

The Indians around Willapa Bay and Quinault Lake in Washington would be photographed and researched on the first part of the journey. The second part would focus on the Kwakiutl tribes along the coast and on northern Vancouver Island.

For the first leg of the journey down the dangerous, mighty Columbia, Curtis and his crew traveled in a small, flat-bottomed craft powered by a feeble gas engine. "Some days swift water and rapids kept us busy just staying right side up," Curtis later admitted. For the second half of the journey into the Pacific, a forty-foot sailboat, the *Elsie Allen*, was purchased. After some hair-raising brushes with treacherous ocean currents, hidden rocks, and whirlpools, Curtis and his crew finally reached Fort Rupert.

The crew dropped anchor near a Kwakiutl village just below the southern tip of Alaska. The Kwakiutl hunted and fished for food from the bountiful seas and coastal rivers. They made use of the vast forests, which grew in some places all the way to the water's edge. To Curtis, this was "inhospitable country, with its forbidding, rock-bound coasts, its dark, tangled, mysterious forests, its beetling mountains, its long, gloomy season of rains and fogs."

The Northwest Coast Indians had developed beautiful artwork—carved and painted wooden masks, drums, and animal figures. They produced inge-

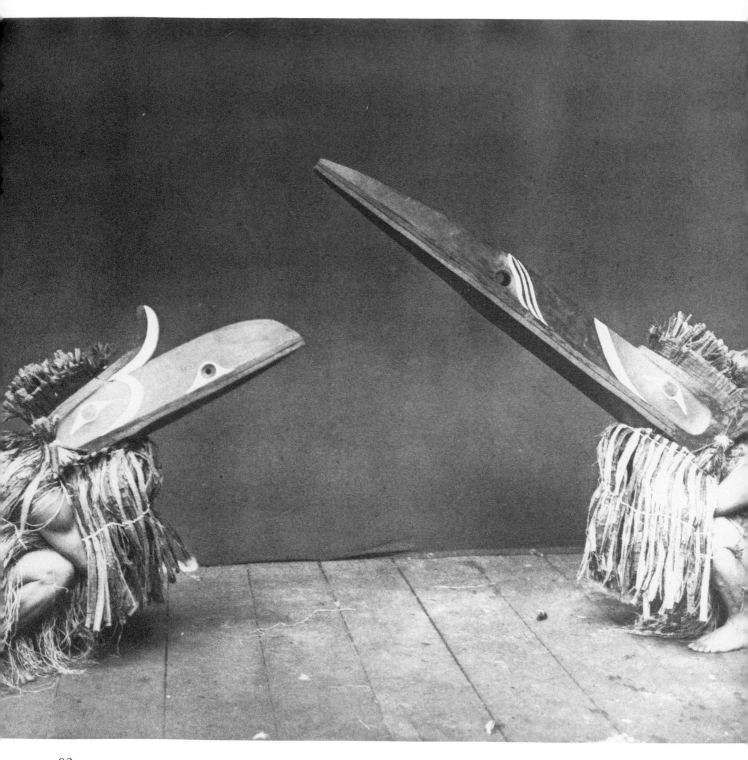

Kwakiutl dancers use strings to open and shut the beaks of their fantastic wooden masks.

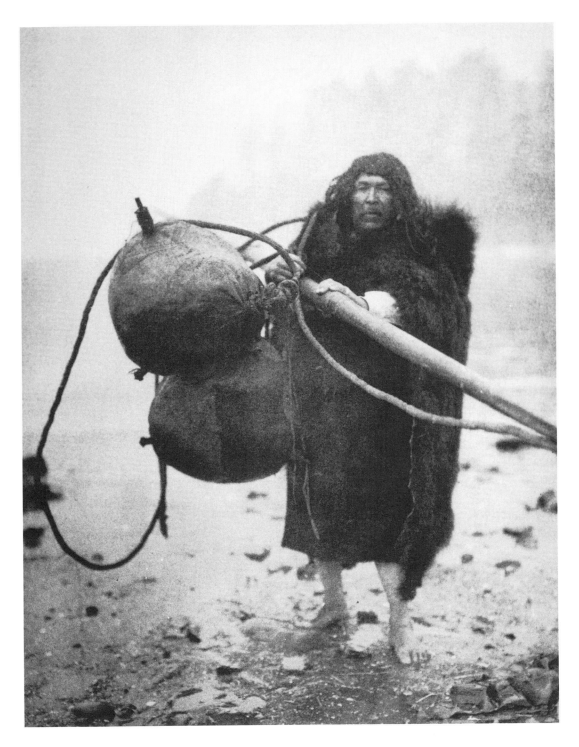

Makah whaler carries a harpoon shaft, which is thrust, not thrown, into the whale. Inflated skins attached to ropes act as flotation devices when the whale dives during the dangerous hunt.

nious hunting equipment and fine canoes. Their rectangular plank homes were spacious and featured tall totem poles representing family clan symbols.

Kwakiutl mythology and ceremonies were dramatic—something that attracted Curtis. All his life, he would remain fascinated by these Indians, whom he visited during five sessions. (The volume on the Kwakiutl, published in 1915, had to be printed on thinner-than-usual paper because there were so many pages.)

The Nootka, the Makah, and Kwakiutl hunted whales for food, building materials and fuel. They used every part of the whale, wasting nothing. Whaling fascinated Curtis, who knew it was the most daring and dangerous hunt of all. The Indians' only instruments in this deadly endeavor were harpoons, spears, lines, and floats—bladders or hide containers filled with air to mark the whale's location once harpooned.

Preparations for whale hunting were secretly handed down from generation to generation. Harpoons and lines had to be made using special methods. There were special rituals for throwing the harpoon and for bringing in the whale after the creature was hit. The harpooner, one of the most respected men in the community, went through intense purification ceremonies to put his spirit in harmony with the whale spirits before the hunt.

But even after performing the lengthy ceremonies and making the necessary preparations, the whale hunters, accompanied by Curtis, came back empty-handed. Curtis was not discouraged, however. On another Kwakiutl whaling expedition a year later, he had his motion-picture camera ready to take exciting footage. The whale had been harpooned and was trying to escape. "I urged the paddlers to move closer. In retrospect I wonder that they obeyed my wish. I wanted a closeup looking into his huge throat. Suddenly I was hurled into the sea and fighting for my life beside that thrashing leviathan."

Curtis gulped for breath. He swam as fast as he could, away from the whale's enormous thrashing tail. "It was a miracle no one had been killed," he said. The canoe was smashed and sank. The camera and priceless film floated to the bottom of the ocean.

A group of Kwakiutl rescued Curtis, who had broken his hip. Even after the injury healed, he would suffer from a limp for the rest of his life.

Perhaps he thought his father was watching over his shoulder. Perhaps he

worried he would appear weak or foolish. Whatever the reason, Curtis did not reveal the story of his "bum leg" or his brush with a whale's tail until nearly forty years later. "My theory has always been that people do not want a tale of woe from a worker as to how hard it is to do a thing, but rather they want results from a worker who managed to keep a smile most of the time."

Managing to keep a smile was about to become harder than ever.

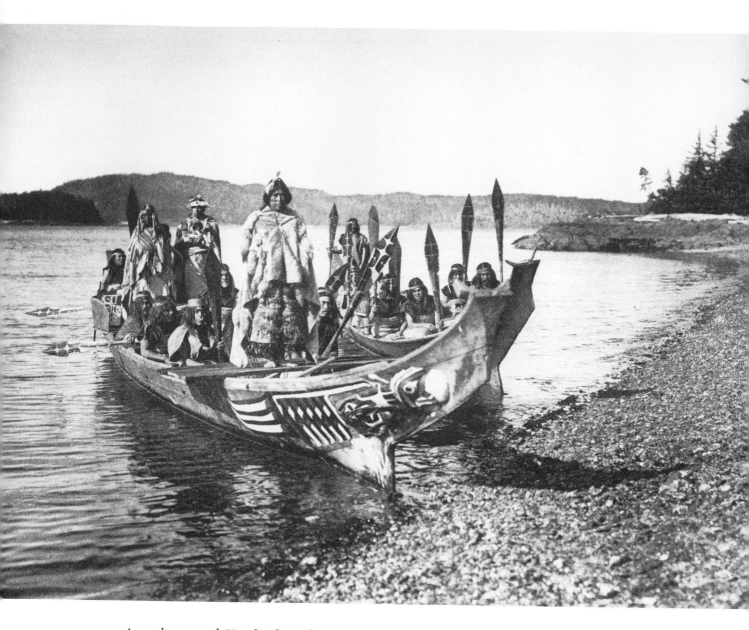

A newly married Kwakiutl couple returns to the husband's home accompanied by singing and rhythmic thumping of paddle handles on the canoe.

CHAPTER NINE

When Curtis and the crew returned from the harrowing season on the Northwest Coast in the fall of 1910, the future of *The North American Indian* looked bleak. Expenses to print the photogravures had skyrocketed. Creditors beat on the door. No one on the staff had been paid a salary in months. The $60,000 that Curtis had managed to convince Morgan to advance only a few months earlier was quickly being eaten away. Curtis's five-year agreement was almost up. He had been able to interest only 200 subscribers in spite of all his hard work and publicity efforts. To get more cash from existing subscribers, he needed to produce more volumes. But another book wouldn't be ready for months.

Now what?

He was going into show business.

In the winter of 1911, Curtis went on the road with "picture musicales" called "The Curtis Indian Picture Opera." This was a new series of lectures featuring lantern slides made from his photographs and accompanied by music from a live orchestra. The music was directly inspired by the wax cylinder recordings of actual Indian music. Curtis hired a booking agent to set up nine performances a week. He targeted every major city. Appreciative audiences in tuxedos crowded Carnegie Hall and the Brooklyn Institute to see and hear his "sophisticated evening entertainment."

But the tour was a financial disaster.

Nine performances a week were too many, the rebellious orchestra complained. They refused to play. Road expenses to feed and house them mounted. Instead of making money, the show was losing $300 a day. "Things are fearfully discouraging, but I am always hoping for the best," Curtis confided in a letter to Hodge in March 1912. In the end, he was forced to close down the show.

Now what?

Curtis was going into moviemaking.

Not just any movie, but a full-length motion picture dramatizing the Kwakiutl way of life. Called *In the Land of the Headhunters*, it would be an original story of "vision quest, love, witchcraft, war, ceremony, revenge, capture, rescue, escape and triumph!" Audiences would love it, Curtis said. Indian-themed pictures were at the peak of their popularity. And he'd make money, he was certain. Weren't moderately successful films making a minimum profit of $100,000? That was just the kind of cash he desperately needed to keep *The North American Indian* afloat.

Right away Curtis raised capital by finding investors and organizing the Continental Film Company. He went to work on writing the script. Filming began in October 1912. No expense would be spared. *In the Land of the Headhunters* must be as true to life as possible, Curtis declared. Energetically, he hired crews to build a village with false fronts and to carve three life-sized totem poles. He insisted on using in the film real masks, cedar bark clothing, authentic robes and capes, and six spectacular canoes, one of which was nearly fifty feet long. He hired George Hunt, an invaluable Kwakiutl interpreter who was the son of a full-blooded Indian and a Scottish employee of Hudson's Bay Company. Many of Hunt's friends and relatives served as actors and actresses. All were paid fifty cents a day, which was considered very good pay.

Work ended on the film in 1914. The first screening was set for the Casino Theater in New York City. One reviewer called the black-and-white film "a gem of the motion picture art." *In the Land of the Headhunters*, which has been called "solid ethnography," included an unmatched scene of a Kwakiutl potlatch. The potlatch was a special celebration in which an individual gave away to others in the tribe all that he or she owned—everything from valuable copper plates to blankets. For years, government agents and pious missionaries on the reservation had forbidden potlatch ceremonies, which were considered "pagan" and "disruptive." Few had ever seen an authentic version of this important aspect of Kwakiutl culture.

"At the base of the whole social system lies the potlatch, or distribution of property among the assembled people," Curtis wrote. "Together with the practice of lending at interest, it provides for a communistic life. No individual can starve or be in serious want so long as there is any property in the posses-

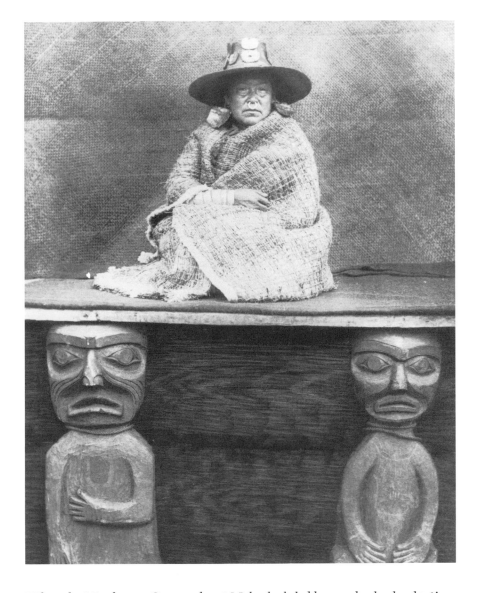

When the Northwest Coast tribe of Nakoaktok holds a potlatch, the chief's eldest daughter is placed on a special throne held up by statues said to represent slaves.

sion of the tribe. . . . The potlatch is intimately bound up with the life of the family. Distributions of property are made whenever a name is changed, a marriage contracted, a dance given, a copper [plate] sold, or, failing any such occasion, whenever a man accumulates a considerable amount of property and wishes to do something for the honor of his name and position. . . . The

feeling at the bottom of the potlatch is one of pride, rather than greed. . . . A man can never receive through the potlatch as much as he disburses, for the simple reason that many to whom he gives will die before they have potlatch and others are too poor to return what he gives them."

In the Land of the Headhunters provided an invaluable record of this important ceremony.

Unfortunately for Curtis and the other investors, *In the Land of the Headhunters* proved to be a financial disaster. No other theater ever booked it. The $75,000 spent to make it was a complete loss. Even more tragically, the 10,000 feet of film slipped into dusty obscurity for the next sixty years.

Even with the "opera" and movie extravaganzas in the works, research and photography for *The North American Indian* continued. Myers, often working on his own without a salary, loyally traveled the country interviewing and recording. Hodge did not give up his editing responsibilities even though he was seldom paid. But it was going to take more than selfless grit and determination to put together another season in the field. Without telling his estranged wife, Curtis took out another loan from a Seattle bank, using their house as collateral. He planned to use the money for field expenses.

The strain of worry and debt showed in a letter Curtis wrote to Morgan's office on March 21, 1913: "I assure you that I have made about every sacrifice a human being can for the sake of the work, and the work is worth it. . . . The lack of comparatively paltry dollars is maddening, and causes me to have a good deal of contempt for man as a whole."

Ten days later, Curtis was shocked to hear that seventy-six-year-old Morgan had died while on vacation in Egypt. What would happen to *The North American Indian* now that its chief benefactor was gone? Curtis admitted that he was "literally numb with apprehension."

Surprise came when Morgan's son, Jack, informed Curtis that the project would be finished. "We have discussed the matter thoroughly and have decided to finish the undertaking as Father had in mind."

Curtis was greatly relieved. But before he could devote himself to finishing fieldwork and photography for the remaining nine volumes, he received more bad news. In November 1913, Muhr, his darkroom genius and studio manager, died. Curtis hurried to Seattle to reorganize the studio. He decided that

responsibility for managing the business would go to two women: Ella Mc-Bride, who had been with his operation for many years, and seventeen-year-old Beth Curtis. Beth, who would remain fiercely loyal in rocky times to come, already showed what her father proudly called the Curtis "business energy and perseverance." She had grown up in the studio, taking photos and learning how to process and retouch negatives. She saw the studio through difficult times in March 1914, when a fire occurred. (Luckily, little damage was done.) Her father, who was in New York at the time, did not rush back to Seattle. He had faith that she and Ella McBride would deal with the difficulty and set the business back in motion again.

Meanwhile, to help buoy the sinking money situation, Curtis lectured. He exhibited his work at the American Museum of Natural History. He wrote a book for children, *Indian Days of Long Ago*, a fictional account of a young Flathead boy living in what is now western Montana. The book was published in 1914. But Curtis's struggles were far from over.

Clara filed for divorce on October 16, 1916. Three years later, following a series of ugly court fights, the breakup would be finalized. In 1919 the courts awarded Clara the studio and all of the negatives—in short, everything Curtis owned. Bitterly, Beth helped carry all of her father's glass negatives to a building across the street. Whether by accident or on orders from Curtis—no one knows for sure—all the plates were broken. In retaliation, before taking over the studio, Clara burned up a trunk filled with letters from her husband.

Beth would have none of her mother's business. She moved to Los Angeles, where she and her father opened a new studio. Beth managed the studio with her father's occasional help. Together they continued to print photographs of Indians made from copies of the original glass plates that had been destroyed. Now there were three Curtis studios: Asahel's and Clara's in Seattle, and Beth's in Los Angeles. None of the Curtis factions were on speaking terms.

Family problems weren't the only difficulties Curtis faced. The printing of *The North American Indian* had ground to a halt. Overseas shipments of fine Dutch paper were no longer possible after German torpedoes sank the American vessel *Lusitania* in the Atlantic on May 7, 1915. The Great War, or World War I as it was later called, plunged the United States and most of Europe into bloody conflict. Americans were no longer interested in Indians. They

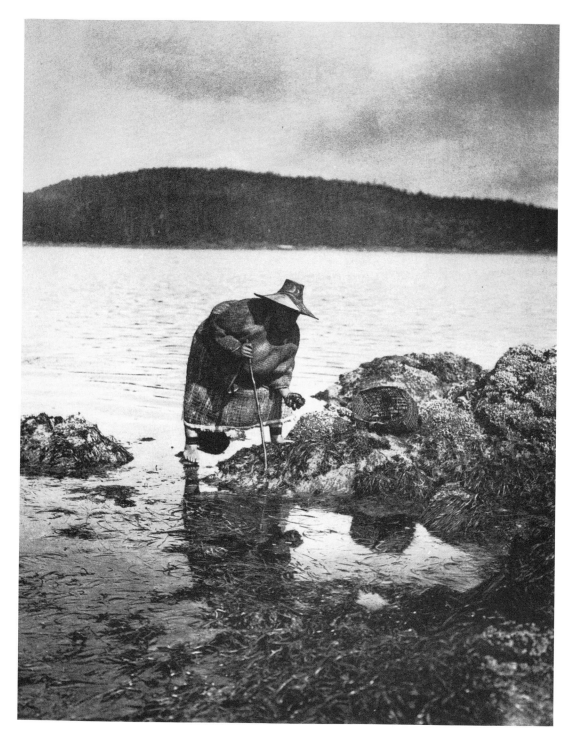

Nakoaktok tribe member wearing a rain-proof cedar bark cape and a hat made of closely woven, shredded spruce roots, gathers abalone along the Northwest Coast.

were fascinated instead by "hate the Hun" photos and films.

Times had indeed changed. The once energetic Teddy Roosevelt was now sickly and partially blind. Curtis's old friend no longer possessed the power he once had among the rich and famous. Many other Curtis patrons had died or lost their fortunes. Meanwhile, Curtis was ignored by young anthropologists. During these dark years, from 1916 to 1922, no new volumes of *The North American Indian* were printed.

Even so, Curtis remained determined to finish what he had begun. Whenever he could scrape together enough of his own money—which wasn't often—he went into the field to take pictures. Throughout this period, he was fortunate to have the loyal support of William Myers, who continued to do research. And Hodge never gave up on the project. He continued working on the editing of the text even though he had not been paid in several years.

To piece together enough funds to complete *The North American Indian*, Curtis dabbled in get-rich-quick inventions. He devised and patented a "gold concentrator" to locate gold in abandoned mines in California. When that didn't work, he went to Hollywood. The town was ten years old and was just beginning to be considered moviemaking paradise. Curtis found a job as a still photographer. One of his many assignments was to photograph movie actor Elmo Lincoln dressed in a fake jaguar skin and swinging through a papier-mâché jungle for the movie *Tarzan*. Curtis also worked for D. W. Griffith, who created the famous movie *Birth of a Nation*, and provided early research for Cecil B. DeMille's *The Ten Commandments*.

Curtis eventually had to give up his own movie to make ends meet. On October 16, 1924, he sold the uncut master print and negatives of *In the Land of the Headhunters* to the American Museum of Natural History. He lost all rights and received only $1,500 for his Kwakiutl film, which had cost countless hours of his own time and so much money to produce.

In spite of these struggles and sacrifices, the completion of *The North American Indian* seemed farther away than ever.

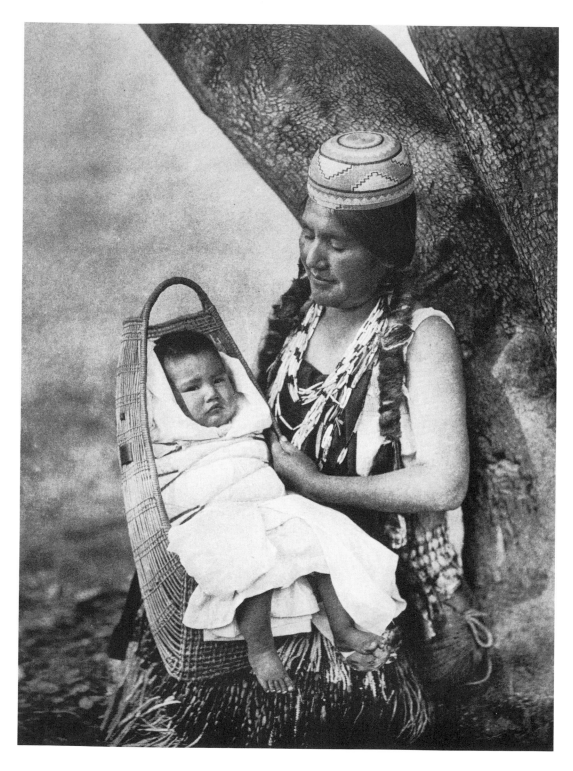

A Hupa mother and child of northwestern California.

CHAPTER TEN

In the summer of 1923, Curtis invited his twenty-four-year-old married daughter, Florence, to come with him to take photographs among the Hupa, Yurok, and Karok Indians of northern California. She had been only seven years old the last time she traveled with her father, by burro and horse and wagon in Canyon de Chelly. This journey would be made by automobile and would involve crossing the coastal mountains seven times, Florence remembered, "on trails widened sufficiently to be called roads."

The various groups of California Indians, who were hunters and gatherers, spoke many different languages. This often made communication through interpreters difficult. What was more challenging was locating the Indians, who avoided contact with whites as much as possible. And with good reason: Their numbers had been greatly reduced by trigger-happy settlers. "The principal outdoor sport of the settlers during the 1850s and 60s seemingly was the killing of the Indians," Curtis wrote to Meany on September 22, 1922. "There is nothing else in the history of the United States which approaches the brutal treatment of the California tribes."

Now restricted to remote reservations called *rancherías*—Spanish for "small ranches"—the Indians were often difficult to locate. Curtis and his daughter drove into the mountains on one-lane dirt roads. Their heavily loaded Chevrolet coupe was nicknamed Nanny because of its goatlike ability to creep over steep passes. In spite of the dangers, Curtis was delighted to be out in the field again.

The trip gave Curtis an opportunity to become reacquainted with Florence, who had seldom seen her father while she was growing up. "For all his brawn and bravery, he was a gentle sensitive man and a wonderful companion," wrote Florence, who was surprised by his impressive skills as a campfire cook. "[Father] had a vast knowledge and kinship with the outdoor world in which he

lived so many months every year. He knew the trees, the animals, the birds and flowers. Camping with him was an unforgettable experience."

The trip also gave Florence a chance to see how her father worked among the Indians. "He was friendly but not the least demonstrative," she recalled, "yet the Indians seemed to sense his sincerity."

When they came upon a new group, Curtis did not waste any time.

"He worked fast. He was deft and sure," Florence wrote. "He knew what he wanted, and he knew when he had it. There was none of the usual fussing. He would make two or three exposures and it was all over, maybe in ten minutes. And he was at it all day long. If he didn't have sun, he took pictures anyway."

Two years later, Curtis experienced unforeseen obstacles when he went to the Southwest to take photos and collect information with Myers. Since his first visit to the Hopi, Zuñi, and Acoma nearly three decades earlier, life on the reservations had changed dramatically. Curtis noticed that old Indian friends no longer welcomed whites the way they once had. Disagreements over education of Indian children and disputes with ranchers over water rights had created a powder-keg atmosphere. Curtis felt fortunate that he had taken so many photos and collected so much information on earlier trips.

In 1922, the twelfth volume—the first in six years—had been printed with money provided by the Morgan family. The Morgans may have renewed their interest in the project when subscribers began complaining directly to the family-owned bank in New York. When were they going to receive the rest of *The North American Indian*? From 1922 to 1926, Curtis worked hard to complete five more volumes. But on April 26, 1926, he received a terrible shock, "like a bolt of lightning out of a clear sky." Myers quit.

After nearly twenty-five years working on the project, Curtis had only two more volumes to complete: one on the Indians of Oklahoma and the other on the Indians of Alaska. How could his right-hand man desert him now?

Myers apologized but did not change his mind. He had promised his wife a European vacation. And he had a chance to make a lot of money on a real estate investment. What had years of unpaid work on the project ever done for his financial future? Nothing. Curtis could understand, couldn't he?

Curtis could not. Their long-standing friendship came to an end.

Frantically, Curtis searched for a replacement before the new field season began. In May 1926 he hired Stewart C. Eastwood of Brandon, Vermont. Eastwood was in his twenties—young enough to be Curtis's son—and had just graduated from the University of Pennsylvania with several courses in anthropology. He went to Oklahoma with Curtis. It soon seemed clear that while he had a good ear for phonetics and vocabulary work, he was still very untried in the field. "I never realized how much knowledge a veteran worker had in his system . . ." the fifty-eight-year-old Curtis confessed in a letter to Hodge. "College and study can not give the knowledge and understanding which comes with long contact with the Indians."

Because he did not entirely trust his new assistant, Curtis did much of the Oklahoma tribe research himself. "We covered the ground with the most intelligent of the present-day educated man as interpreter and helper," Curtis wrote to Hodge. "With his help, we talked with all of the old men of the tribe."

Curtis, Eastwood, and their interpreter struggled to gather material about ancient rites, beliefs and customs, but soon found themselves frustrated because so much information had not been passed from generation to generation as part of the Indian oral tradition. Years of reservation poverty, hopelessness, and forced acculturation to white society had taken a tragic toll. Many of the old ways had been forgotten.

In spite of the difficulty of gathering the kind of material he had hoped for, Curtis and his new assistant began the writing and editing process in early 1927. When the text on the Oklahoma tribes was finished, Curtis sent it on to Hodge. He was surprised when Hodge returned it with a critical letter regarding Eastwood's work.

Eastwood threatened to quit. Angrily, Curtis wrote back to Hodge on May 11: "You're a good editor but certainly a bum diplomat. It may seem necessary to wield a club—even so, one might to advantage . . . pad the club. It has taken a lot of quick figuring and hard talking to keep the boy in line. To have him drop out at this last moment would wreck the ship."

There wasn't time to make corrections in the manuscript. Curtis had already made plans to sail in June on the first steamer bound for Alaska. He and Eastwood would work on the manuscript when they returned on the last

steamer south in September. Ambitiously, Curtis hoped to cram into one season "the work of at least three seasons" among the Inuit of the Bering Sea. There was no way, of course, for Curtis to know that this, his last trip, would be the most dangerous and exhausting yet.

On June 28, 1927, Curtis, Eastwood, and a boat pilot named Harry the Fish left the city of Nome, Alaska, and set sail for the far reaches of the state. Thirty-one years earlier Curtis had taken almost the same route with the Harriman expedition. Now he was returning—older, wiser, and almost as enthusiastic as he had been in those early days when anything seemed possible. The end of his work was in sight. When he completed the research and photography for Volume 20, *The North American Indian* would at last be finished.

Joining the adventurers was Curtis's daughter Beth. Beth had provided her father with the financial and emotional support necessary to make the trip. She

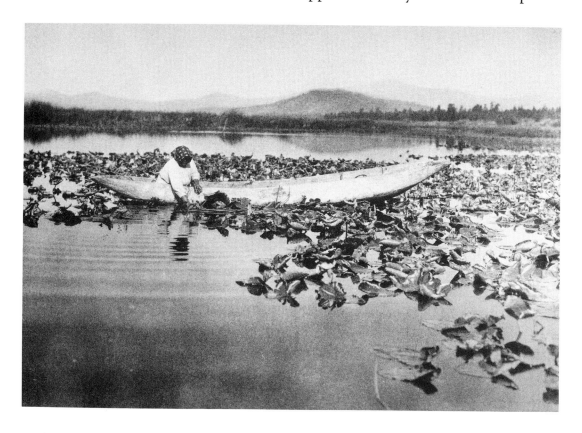

In late August ripe water lily pods are gathered by a member of the Klamath tribe on the Northwest Coast.

had also been key in persuading him to keep a daily journal of the voyage, something he had never bothered with before.

From the start the trip was a race against time. Once winter set in, ice could easily trap Curtis and the others until the following spring. Their temperamental forty-foot sailboat, *Jewel Guard*, was no match for the unpredictable ice floes that crippled or sank countless ships each year. "It was an ideal craft for muskrat hunting in the swamps," Curtis said, "but certainly never designed for storms in the Arctic Ocean." Without modern radio equipment, there would be no way to signal a rescue ship if trouble arose.

Rough weather hit almost immediately. "Ice thick, headway slow," Curtis wrote in his journal as *Jewel Guard* began her 300-mile voyage to Nunivak Island, off the western coast of Alaska in the Bering Sea. "Fog closed down so cannot see two boat lengths. Danger of collision with ice." Curtis remained on watch while everyone slept. He listened nervously to the howling wind and groaning, shifting ice.

After a week at sea, another brutal storm broke. "The sea was wild and growing worse. It was a spar[r]ing match with one big swell after the other. With full power we could make a mile an hour and each breaker looked as though it might be our finish." Finally, they were able to hide behind a sand spit, where they planned to lie at anchor for a few hours. By then, Curtis hoped, the storm would subside. But they would not be so lucky.

When *Jewel Guard* edged back out to sea, waves pummeled her. "As she climbed a big swell," Curtis wrote, "I eased her off slightly and as she came to the crest, threw her hard over. Being flat-bottomed, she spun on the crest of the swell like a tin pan and in a flash we were about and running before the wind like a scared Jackrabbit."

Blinded by thick fog that night, the boat hit a shoal. The engine died. Waves battered the beached craft and nearly knocked Curtis and the rest of the crew overboard. As the tide fell, the boat became solidly grounded, almost twenty miles from shore. Now what?

Secretly, Curtis worried about his chances of survival. Could he make it to shore if they were suddenly forced to become island castaways? "The condition of my lame hip is causing me a lot of anxiety as I can only go as far as we can get in a boat," he confessed in his journal, referring to the injury that had

plagued him since the whaling accident nearly sixteen years earlier. "I could not walk a mile if all our lives depended on it."

At dawn the tide began to come in. The boat was lifted slowly from the shoal. Finally, at six that night, *Jewel Guard* escaped from her prison. "Oh, Boy! What a relief it was to feel her floating free!" Curtis wrote exultantly. To celebrate, he fixed everyone a dinner of eider duck with dumplings and tapioca pudding with apples.

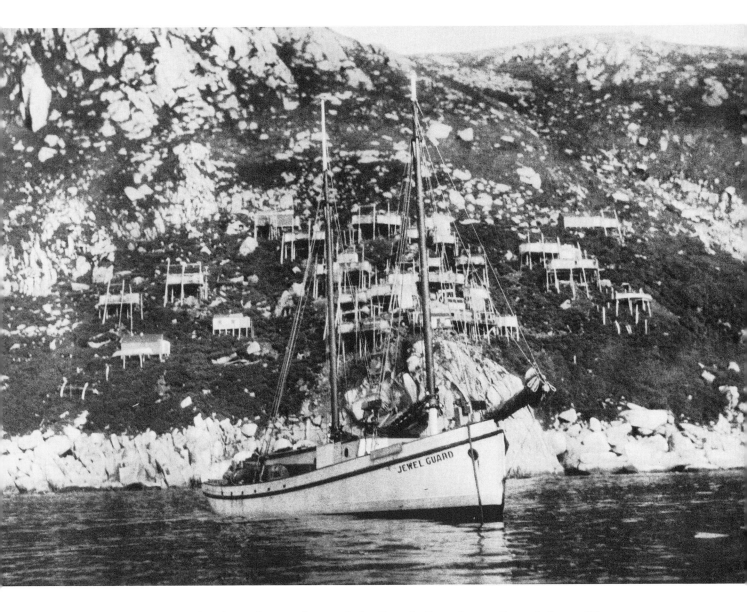

For six weeks, while taking photographs in Alaska, Jewel Guard was Curtis's home. The forty-foot boat is pictured here moored off King Island.

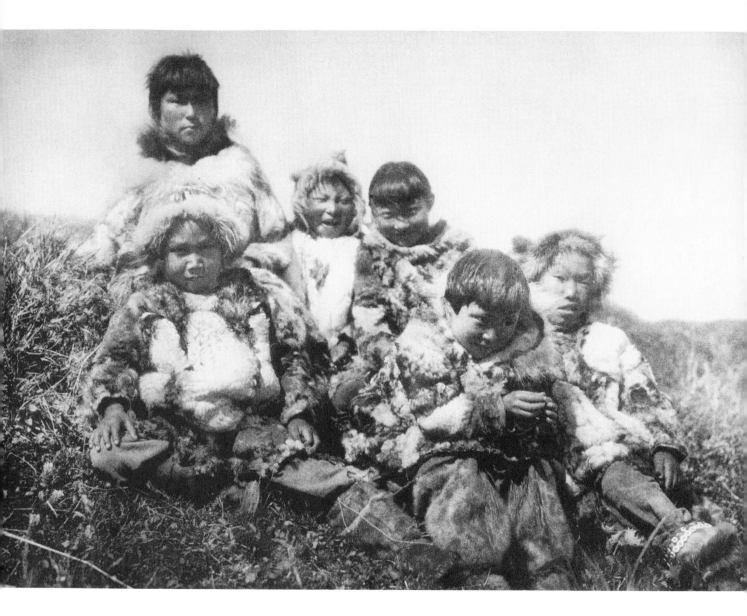

A group of Nunivak children smile for Curtis's camera.

CHAPTER ELEVEN

*J*ewel *Guard* arrived at Nunivak Island on July 10, nearly twelve days after Curtis and his crew had left Nome. The trip that was supposed to take three days took four times as long. If Curtis worried about the lost time, he did not reveal his feelings in his journal. For the moment, he was delighted by the prospects of photographing and investigating the natives of Nunivak Island. He hired as his interpreter Paul Ivanoff, who was Russian and Inuit (Eskimo).

The Inuit of Nunivak and the other islands in the Bering Sea had survived for centuries by adapting to a hostile, often treeless environment. The weather was harsh and unpredictable. Few natural resources were available. Over the centuries the Inuit had learned to work with whatever was at hand—bone, hide, sinew, rock, and occasional pieces of driftwood—to make everything from spears and harpoons to sleds and kayaks. Warm clothing was fashioned from the skins, fur, or feathers of caribou, seal, polar bear, fox, duck, and even dog. Hunting was done in sleek, swift, maneuverable kayaks made from skins of seal or caribou stretched over a driftwood frame. Inuit hunters used umiaks—larger, open, hide-covered boats as much as thirty feet long. Depending on the season, the Inuit fished or hunted seals or whales in cooperative groups.

What surprised and delighted Curtis was how untouched by white culture the Nunivak Inuit were. "At last, and for the first time in all my thirty years work with the natives I have found a place where no missionary has worked," he wrote. "I hesitate to mention it for fear that some over-zealous sky pilot will feel called upon to 'labor' these unspoiled people. . . . Should any misguided missionary start for this island, I trust the sea will do its duty." For the next several days, Curtis eagerly took pictures of hunters in kayaks, of family groups, and of smiling children.

With his research finished, Curtis set a course for Nome, where Beth had to part from the group to return home. She said a tearful good-bye to her

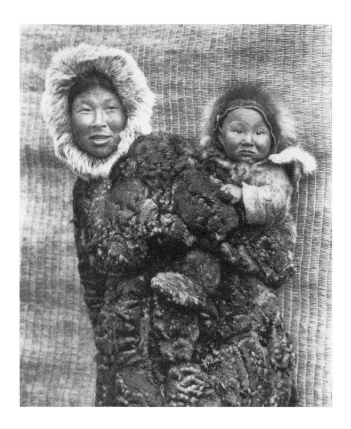

Mother and child—Nunivak.

father and climbed aboard a small airplane. (She was the first woman to fly from Nome to Fairbanks.) But her departure was anything but triumphant. She recalled feelings of foreboding: "I was so fearful I would never see [my father] again."

Curtis's health was not good. His hip ached. But he tried to keep up his spirits. There was still so much to do, and so little good weather left in the season. They must push forward. On August 7, 1927, *Jewel Guard* set sail for King Island, located at the south end of the Bering Strait. At this point, Curtis's bad leg caused him so much pain that he could not stand. "One might wonder how a person can manage this sort of trip with a bad leg," he wrote casually in his journal. "The how of it is that I sit down while at the wheel, that is, when it is not too stormy, and do all the cooking sitting down. From my stool I can reach the stove, the dish and food locker and the table. I often prepare a meal, serve it, and do up the dishes without getting to my feet." On a darker note he added, "My fear from the start has been that I might become completely disabled but I am keeping up well and I do not think my hip is much worse than when I started. . . . I suspect it is fortunate that this is the last volume as I have a feeling that this thing may be permanent. Let us hope not."

Later that day, Curtis and the crew saw the first—and last—passenger ship coming across the Arctic from the Diomede Islands. "One swimming about here waiting for a passing craft to pick him up would have a long wait," he joked, knowing full well that anyone unlucky enough to plunge into the icy water would not survive more than a few minutes.

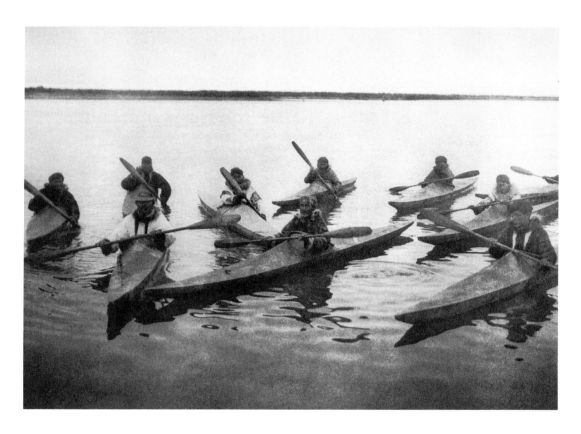

Noatak kayakers. Each kayak is unique, built to the owner's exact size and weight.

When *Jewel Guard* finally reached King Island at midnight, "the darkest and worst hour," the sea became strangely calm. Even so, Curtis found it difficult to find a place to anchor the ship: the island was nothing more than a sheer rock pinnacle. The place was mysteriously silent. Where were the inhabitants? Suddenly, a terrible howling filled the air.

An enormous pack of apparently wild dogs descended on Curtis and the crew as soon as they stepped ashore. The dogs belonged to the King Island Inuit, who had left them behind temporarily while hunting game elsewhere. Fortunately, the "large wolf-like beasts" were friendly—a bit *too* friendly: "They were so glad to see a human that they almost crushed us with their affection," Curtis wrote. "They gathered about us so thick that it was difficult to walk. Every dog in the pack tried to get close enough to touch us. Half a dozen at a time would jump up and try to get their paws on our shoulders, and countless dog fights resulted from this rivalry to be our pals."

The dogs joyfully leaped and rolled underfoot, knocking Curtis's camera off its tripod. Nevertheless, he managed to take pictures of the deserted village. The twenty-nine houses stood on stilt legs buried in terraces that scaled the island. "This bleak, forbidding, rocky mass supports few varieties of growing things," Curtis wrote.

In spite of its barren appearance, King Island was located in an area rich in the food and materials Inuit needed to survive. In the Inuit world, the Bering Strait was one of the areas richest in fish, sea and land mammals, plant food, birds, and eggs. Every spring and fall, King Island became a prime walrus-hunting site. In early May, walruses lumbered onto distant floes of ice. By June, large herds swam past the island. During the fall, walruses could be spotted in the water of the ice pack.

Walruses provided a bonanza of food and raw materials for the Inuit. While one cow, or female, could attain a maximum weight of 2,000 pounds, a bull, or male, might weigh nearly 4,000 pounds—nearly a ton of which was meat. Walrus tusks were carved into tools. The thick skins of cows or young bulls were used to make coverings for umiaks and kayaks. A large boat between thirty-five and forty feet in length required the split skins of three walruses. The skins of young walruses were cut into soles for mukluks—boots—or were dehaired and dried to create coverings for the Inuit summer houses, like those Curtis saw on King Island.

When Curtis left the island, he headed boldly north to Cape Prince of Wales in the Bering Strait—the most westerly point on the North American continent. There he picked up an interpreter who would travel with them for the last leg of the trip.

With a stiff wind in her sails, *Jewel Guard* made good time. For once, the weather seemed to cooperate. Curtis hoped to reach the island of Little Diomede quickly, even though he had been warned that locating it was no easy matter. Fog rolled in unexpectedly. But Curtis's luck held. The weather cleared enough for the crew to locate Little Diomede at midnight. By early morning the next day, Curtis was ashore taking pictures. "I quickly changed to a long focus lens and with my tripod standing on American soil, I photographed sections of Siberia."

Jewel Guard then headed west to Big Diomede, just three miles from Siberia.

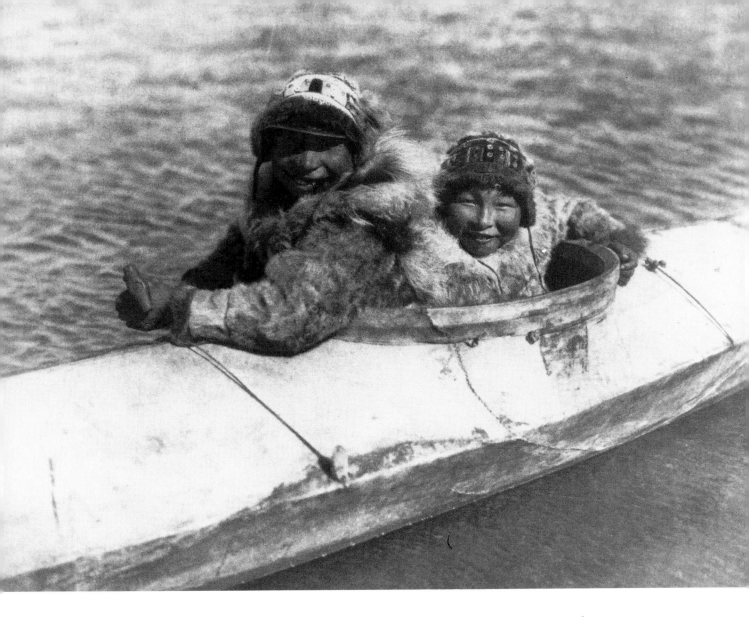

Curtis wrote: "Eskimo boys are trained in manly pursuits from their earliest years and are honored with feasts on taking their first game."

Curtis managed to get ashore to take pictures during part of one day. The threat of rough seas forced him to move the boat around the island, where he and the crew were caught in a storm that raged for sixty sleepless hours. When the storm finally ended, the Inuit on Big Diomede were surprised to see Curtis and his crew come ashore. They assumed *Jewel Guard* had sunk. From that point on they called her *Ghost Ship*.

In spite of the lateness of the season and his own failing physical condition,

Curtis refused to give up on his plan to sail above the Arctic Circle. "A week with no sleep to speak of has about done me out," he confessed in his journal. He went ashore to take pictures and interview the Inuit of Kotzebue, an early whaling and fur-trading center on the western coast of Alaska.

While seals were hunted by the Inuit for skin, oil, and meat, the people of Kotzebue Sound relied heavily on fish for survival through the long winter. By late July, racks were full of salmon split in half to dry and preserve the meat. Partly dried salmon eggs were packed into barrels with seal oil. Curtis may not have had time to enjoy such delicacies. Winter sea ice was already growing. He knew he had to head south as soon as possible.

The journey home was a desperate race. Battered by snow, ice, and fierce winds, *Jewel Guard* developed a leak. Water filled the hold. But there was no time to stop to make repairs. In a matter of days, they might easily be trapped by ice. Curtis and the crew kept the pump running, bailed by hand, and raced south. "The finish of our cruise is getting interesting if not a bit sporting," he wrote in his journal.

Jewel Guard managed to survive the punishing wind and made it safely to Nome, where a large, amazed crowd gathered at the landing to greet the weary travelers. The last telegraphed message had reported that Curtis and his men were "no doubt wrecked in the first big winter blizzard."

Once again, Curtis seemed to have beaten the odds.

But he was not so lucky when he returned to Seattle on October 12, 1927, haggard and physically ill. As soon as he set foot on solid ground, he was arrested. Deputy sheriffs and "operatives of the Burns Detective Agency" dragged him to the county jail.

Clara Curtis had had her former husband arrested for "failure to pay alimony which has now accrued to the tune of $4,500," a Seattle newspaper reported. This court action was reportedly one of perhaps twenty that had been filed by Curtis or his former wife over the past eight years.

Newspaper coverage of the three court appearances during the next several days must have been deeply humiliating for Curtis. He tried to explain to the judge that he had no money to give his former wife.

The judge did not believe this. If Curtis wasn't being paid for *The North American Indian*, why had he spent so much time doing it? At that point, Curtis broke down. The newspaper reported: " 'Your Honor,' . . . 'it was my job. The only thing I could do which was worth doing. . . . A sort of life's work. . . . [I] was duty bound to finish. Some of the subscribers had paid for the whole series in advance.' "

Eventually, Seattle reporters and gossips lost interest in the Curtis divorce squabble. Edward Curtis returned to Los Angeles, feeling exhausted and betrayed. He and Eastwood went to work on volumes nineteen and twenty. Volume eighteen was published in 1929. The last two volumes appeared the following year. In the introduction to the last volume, Curtis gratefully acknowledged the help of the Morgans, who had spent almost $400,000— about one-quarter the total cost of the entire project. He ended by writing, "Great is the satisfaction the writer enjoys when he can at last say to all those whose faith has been unbounded, 'It is finished.' "

Edward Curtis, 1951; photograph taken for his eighty-third birthday. Eighteen months later he died. (Photographer unknown. Reproduced with permission of Special Collections Division, University of Washington Libraries, WW 2805)

CHAPTER TWELVE

In 1930, when *The North American Indian* was completed, Curtis was sixty-two years old. Arthritis and hip problems plagued him. His leg ached. He was deep in debt and had no job. Little wonder, perhaps, that he spent the next two years in "a complete, physical breakdown." He later wrote, "Ill health and uncertainty as to how I was to solve the problem of the future brought a period of depression which about crushed me. Lacking the courage to do the obvious thing, I fought up and out of the mire of despondency."

With medical help and a great deal of his own effort, he managed to pull himself together. By 1932 he was again writing to old friends to say that he was "hoping to do something worthwhile." To Meany he confided, "Yes, I am certainly broke. Other than that, I am not down and out."

Curtis never allowed himself to be down and out for long. He tried to revive interest in his gold "concentrator" and dabbled in some mines in Colorado. He scouted for new mines on what he called his "hobo wandering." He worked as a still photographer on a Hollywood film set in South Dakota. He raised chickens, ducks, and avocados on a small farm in Whittier, California. "As I look back over my scrambled life," he wrote in his seventies, "I realize that I have rarely taken a Sunday off and but one week's vacation, it's safe to say that in the past sixty years I have averaged sixteen hours a day, seven days a week. Following the Indians' form of naming men I would be termed The Man Who Never Took Time to Play."

Although he was often so crippled by arthritis that he could "scarcely hold a pencil," Curtis spent the last years of his life on an ambitious new project he hoped would span 200 years of American history. He called the book *The Lure of Gold*. With vigor and hope reminiscent of his earlier days, he plastered two walls of his cramped apartment in Los Angeles with research notes.

Even at age eighty, he still had dreams of exploring and mountain climbing. He wanted to travel up the Amazon River and visit the Andes Mountains.

When the daring trip he planned was unexpectedly canceled, he confided to a friend, "No words can express my disappointment."

Until the end of his life, he kept in close contact with all his children, including Harold. Billy helped type some of his memoirs. Curtis once wrote that he and Billy were "real pals." He also corresponded with a Seattle librarian named Harriet Leitch. Throughout their correspondence, which lasted from 1948 to 1951, he maintained his indefatigable sense of humor and upbeat charm. "Old Man Curtis," as he often called himself, was more than happy to send Miss Leitch a photograph taken on his eighty-third birthday. ("Most of my friends insist I look younger," he noted gleefully.)

Curtis insisted the portrait made in 1951 not be retouched, unlike the studio photo taken in 1899 when he was thirty-one and in his prime. "I am glad you like the quizzical expression on the old face," he wrote to Miss Leitch. His beard was nearly white; his face was lined. He wore glasses to help his failing eyesight. All that was reminiscent of the 1899 photograph was his broad-rimmed hat, jauntily set at the same hopeful, go-ahead-anyway angle.

On October 19, 1952, eighteen months after this portrait was taken, Edward Curtis died of a heart attack at Beth's home in Los Angeles. *The New York Times*, in a very short obituary, described him as an authority on the history of North American Indians. "Mr. Curtis was also widely known as a photographer."

At the time of his death, however, Curtis's monumental life's work had been almost completely forgotten. Fewer than 300 copies of *The North American Indian* were ever printed. Most lay gathering dust, hidden in the back shelves of libraries or secondhand bookstores. Many of the original glass plate negatives, which had been stored until the 1940s in the basement of the Morgan Library in New York, were destroyed or thrown out "as junk." Not until 1972 were the original copper photogravure plates discovered in the basement of a Boston bookstore.

Reprints of haunting images from *The North American Indian* began appearing in publications during the 1970s. Public interest was fueled by a growing awareness of Native American culture of the past and the present. The civil rights movement, which had gathered steam in the 1960s, helped to push forward reforms in laws to establish and protect the rights of Indian people,

both as human beings and as members of tribal communities. Far from "vanishing," as some had predicted when Curtis began his project in 1890, the Native Americans a century later numbered 1,959,234, according to the 1990 United States census.

Many non-Indians have found that they, too, could learn much from Native American history, culture, and commitment to appreciating and preserving the natural world. The public has once again become fascinated by early Native American images. As a result, Edward S. Curtis's portraits of Indian men, women, and children are appearing in books, films, magazines, newspapers, posters, and calendars (although not always with proper credit).

In spite of years of obscurity and neglect, Curtis's photographs have never diminished in their power to inspire and intrigue. They are the legacy of the "Shadow Catcher" who refused to give up, the artist whose vision continues to endure.

A P P E N D I X

The Twenty Volumes of The North American Indian

Curtis, Edward S. The North American Indian. *20 volumes. Volumes 1–4, Cambridge, Mass.: The University Press, 1907–9. Volumes 6–20, Norwood, Conn.: Plimpton Press, 1907–30. New York and London: Johnson Reprint Corp., 1970.*

Volume 1, 1907: Apache, Jicarilla Apache, Navajo

Volume 2, 1908: Pima, Papago, Quahatika, Mahave, Yuma, Maricopa, Havasupai, Apache-Mohave

Volume 3, 1908: Teton Sioux, Yanktonai, Assiniboin

Volume 4, 1909: Apsaroke, Hidatsa

Volume 5, 1909: Mandan, Arikara, Atsina

Volume 6, 1911: Piegan, Cheyenne, Arapaho

Volume 7, 1911: Yakima, Klickitat, Interior Salish, Kutenai

Volume 8, 1911: Nez Percé, Walla Walla, Umatilla, Cayuse, Chinookan

Volume 9, 1913: Coast Salish, Chimakum, Quilliute, Willipa

Volume 10, 1915: Kwakiutl

Volume 11, 1916: Nootka, Haida

Volume 12, 1922: Hopi

Volume 13, 1924: Hupa, Yurok, Karok, Wiyot, Tolowa, Tututni, Shasta, Achomawi, Klamath

Volume 14, 1924: Kato, Wailaki, Yuki, Pomo, Wintun, Maidu, Miwok, Yokuts

Volume 15, 1926: Southern California Shoshoneans, Dieguenos, Plateau Shoshoneans, Washo

Volume 16, 1926: Tiwa, Keres

Volume 17, 1926: Tewa, Zuni

Volume 18, 1928: Chipewyan, Cree, Sarsi

Volume 19, 1930: Wichita, Southern Cheyenne, Oto, Commanche

Volume 20, 1930: Nunivak, King Island, Little Diomede Island, Cape Prince of Wales, Kotzebue

Note: Dates accompanying volume numbers correspond to the years the volumes were printed and not necessarily to the years the photographs were taken.

Text Photographs from The North American Indian

SELECTED BIBLIOGRAPHY FOR CHILDREN

BOOKS ABOUT INDIANS

Andrews, Elaine. *Indians of the Plains.* New York: Facts on File, 1990. (This is part of an eight-volume series, which also includes *California Indians, Indians of the Arctic and Subarctic, Indians of the Northeast, Indians of the Pacific Northwest, Indians of the Plateau and Great Basin, Indians of the Southwest,* and *Indians of the Southeast.*)

Ashabranner, Brent. *To Live in Two Worlds: American Indian Youth Today.* New York: Dodd, Mead, 1984.

Batdorf, Carol. *Gifts of the Season: Life Among the Northwest Indians.* Blaine, Wash.: Hancock House, 1990.

Bierhorst, John. *The Hungry Woman: Myths and Legends of the Aztecs.* New York: William Morrow. 1984.

————. *The Mythology of North America.* New York: William Morrow, 1985.

————, editor. *The Sacred Path: Spells, Prayers and Power Songs of the American Indians.* New York: William Morrow, 1983.

Boss-Ribs, Mary C. and Jenny Running-Crane. *Stories of Our Blackfeet Grandmothers.* Billings, Mont.: Council for Indian Education, 1984.

Cohen, Fay G. and Jeanne Heuving, editors. *Tribal Sovereignty: Indian Tribes in U.S. History.* Seattle, WA: Daybreak Star Press, 1981.

Dameron, John. *Sequoyah and the Talking Leaves: A Play.* Park Hill, Oklahoma: Cross Cultural Educational Center, 1984.

Ekoomiak, Normee. *Arctic Memories.* New York: Henry Holt, 1990.

Erdoes, Richard. *The Sun Dance People: The Plains Indians, Their Past and Present.* New York: Knopf, 1972.

Franklin, Paula A. *Indians of North America: The Eight Culture Areas and How Their Inhabitants Lived Before the Coming of Whites.* New York: David McKay, 1975.

Freedman, Russell. *Indian Chiefs.* New York: Holiday House, 1987.

————. *An Indian Winter.* New York: Holiday House, 1992.

Green, Ryan. *Women in American Indian Society.* New York: Chelsea House, 1992.

Grinnell, George Bird. *The Whistling Skeleton: American Indian Tales of the Supernatural.* Four Winds, 1982.

Henry, Edna/We-Cha-Pi-Tu-Wen, Blue Star Woman. *Native American Cookbook.* New York: Julian Messner, 1983.

Hirschfelder, Arlene. *Happily May I Walk: American Indians and Alaska Natives Today.* New York: Charles Scribner's Sons, 1986.

Hoxie, Frederick. *The Crow.* New York: Chelsea House, 1989.

Hoyt-Goldsmith, Diane. *Arctic Hunter.* New York: Holiday House, 1992.

————. *Pueblo Storyteller.* New York: Holiday House, 1991.

————. *Totem Pole.* New York: Holiday House, 1990.

Kelly, Lawrence C. *Federal Indian Policy.* New York: Chelsea House, 1990.

Kowes, Kati. *Nez Perce.* Vero Beach, Fla.: Rourke Publications, 1990.

Iverson, Peter J. *The Navajos.* New York: Chelsea House, 1990.

McLuhan, T. C. *Touch the Earth.* New York: Dutton, 1972.

Nabokov, Peter, ed. *Native American Testimony.* New York: Viking, 1978.

National Geographic Society. *The World of the American Indian.* Washington, D.C.: National Geographic Society, 1979.

Sneve, Virginia H., ed. *Dancing Teepees: Poems of American Indian Youth.* New York: Holiday House, 1990.

Williams, Terry Tempest and Ted Major. *The Secret Language of Snow.* Sierra Club/Pantheon, 1984.

Wolfson, Evelyn. *From Abenaki to Zuñi: A Dictionary of Native American Tribes.* New York: Walker and Company, 1988.

Wood, Ted, with Wanbli Numpa. *A Boy Becomes a Man at Wounded Knee.* New York: Walker and Company, 1992.

BOOKS BY OR ABOUT EDWARD S. CURTIS

Boesen, Victor, and Graybill, Florence Curtis. *Edward S. Curtis: Photographer of the North American Indian.* New York: Dodd, Mead, 1977.

————. *Edward Sheriff Curtis: Visions of a Vanishing Race.* New York: Crowell, 1976.

Curtis, Edward. *Indian Days of Long Ago.* Yonkers-on-Hudson, N.Y.: World Book Co., 1914. Reprint ed.: Berkeley, Cal.: Ten Speed/Tamarack Press, 1975.

Davis, Barbara. *Edward S. Curtis: The Life and Times of a Shadow Catcher.* San Francisco: Chronicle Books, 1985.

Fowler, Don. *In a Sacred Manner We Live: Photographs of the North American Indian by E. S. Curtis.* Barre, Mass.: Barre Publishing Co., 1972.

Lyman, Christopher M. *The Vanishing Race and Other Illusions: Photographs by Edward S. Curtis.* New York: Pantheon Books in association with the Smithsonian Press, 1982.

BOOKS ABOUT PHOTOGRAPHY

Chiaramonte, Giovanni. *The Story of Photography: An Illustrated History.* Milan, Italy: Aperture, 1983.

Czaja, Paul C. *Writing with Light: A Simple Workshop in Basic Photography.* Old Greenwich, Ct.: Chatham Press, 1973.

Morgan, Terri and Shmuel Thaler. *Photography: Take Your Best Shot.* Minneapolis: Lerner Publications, 1991.

Owens-Knudsen, Victor. *Photography Basics: An Introduction for Young People.* New York: Prentice-Hall, 1983.

Peach, S. and M. Butterfield. *Photography.* Tulsa: EDC Publishing, 1987.

Steffans, Bradley. *Photography: Preserving the Past.* San Diego: Lucent Books, 1991.

INDEX